Sweet & Creepy Coloring

Over 60 Enchanting Images of Ghosts, Witches, and Cozy Haunted Places

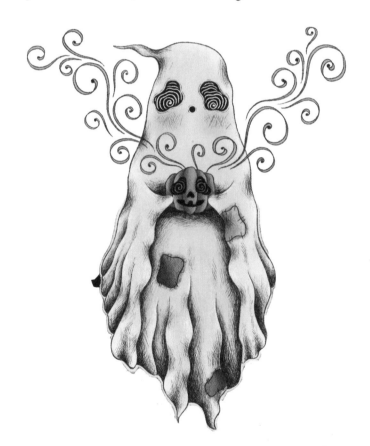

Illustrations by Kitty Willow Wilson

ROCK
POINT

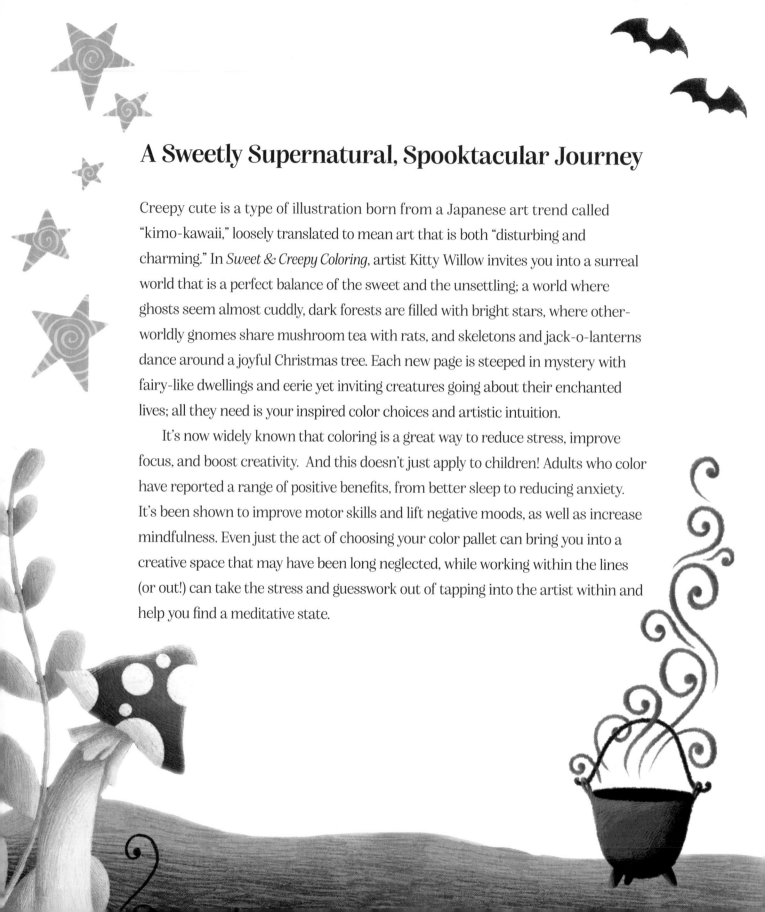

A Sweetly Supernatural, Spooktacular Journey

Creepy cute is a type of illustration born from a Japanese art trend called "kimo-kawaii," loosely translated to mean art that is both "disturbing and charming." In *Sweet & Creepy Coloring*, artist Kitty Willow invites you into a surreal world that is a perfect balance of the sweet and the unsettling; a world where ghosts seem almost cuddly, dark forests are filled with bright stars, where other-worldly gnomes share mushroom tea with rats, and skeletons and jack-o-lanterns dance around a joyful Christmas tree. Each new page is steeped in mystery with fairy-like dwellings and eerie yet inviting creatures going about their enchanted lives; all they need is your inspired color choices and artistic intuition.

It's now widely known that coloring is a great way to reduce stress, improve focus, and boost creativity. And this doesn't just apply to children! Adults who color have reported a range of positive benefits, from better sleep to reducing anxiety. It's been shown to improve motor skills and lift negative moods, as well as increase mindfulness. Even just the act of choosing your color pallet can bring you into a creative space that may have been long neglected, while working within the lines (or out!) can take the stress and guesswork out of tapping into the artist within and help you find a meditative state.

What Will You Find on the Other Side?

Coloring at any time will help you achieve these goals, but creating a routine is most beneficial. Try setting aside a set amount of time to dedicate to this book before you go to bed. This will help relax your mind and take you away from your screen, be it television, phone, tablet, or computer. If your days tend to be busy with little time to think, grab a cup of your favorite coffee or tea and begin your day with a few minutes of meditative coloring to set a calm and collected tone to the rest of your day. Take it with you to pass the time peacefully during a long trip, or just sit down with your coloring book any time you feel the need to tune-out and relax.

Sweet & Creepy Coloring is designed to pull your racing mind away from traffic jams, your demanding boss, the anxiety of too much screen time, or any of the daily stresses we face in our adult lives, and step into a world of your own imagination. Press pause on reality and instead, attend a ghost's magical birthday party, gaze at a star-filled sky with a chatty snail, finally meet that Frog Prince, or chase butterflies with a winged fox.

So, grab your colored pencils, crayons, or markers, unwind, and get coloring!

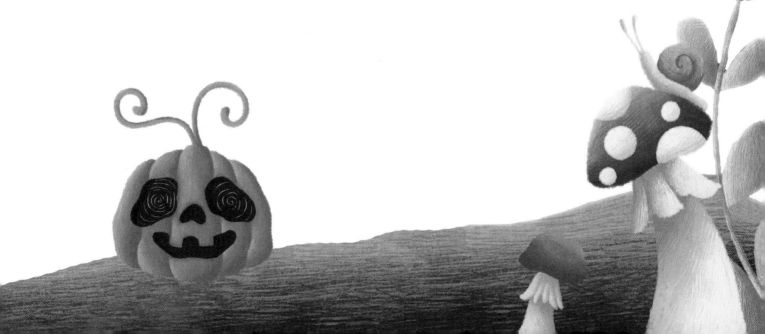

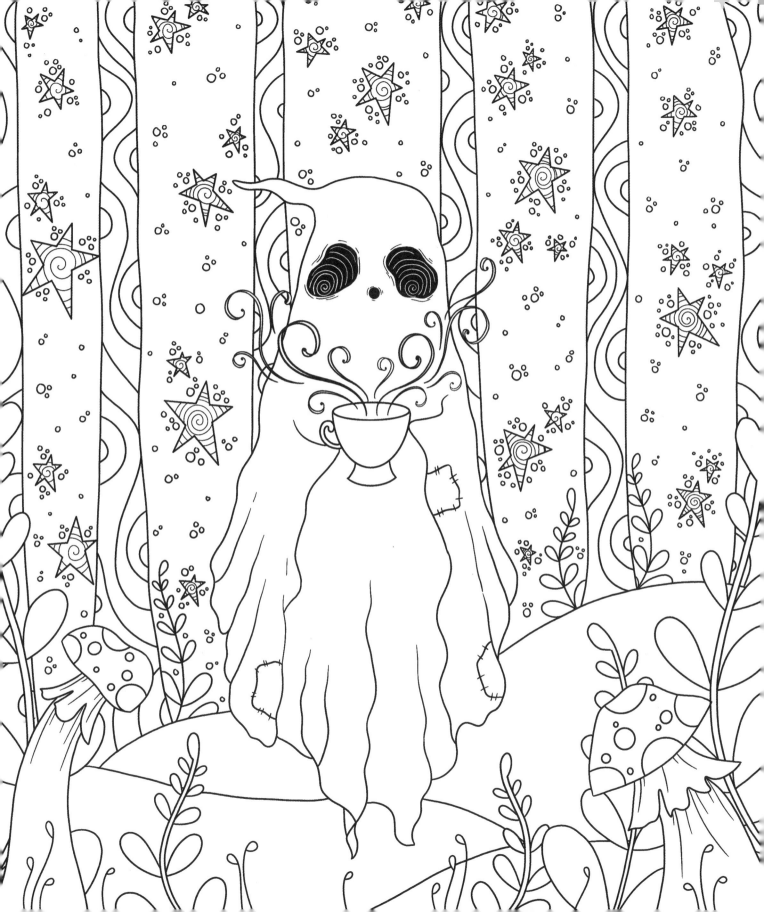

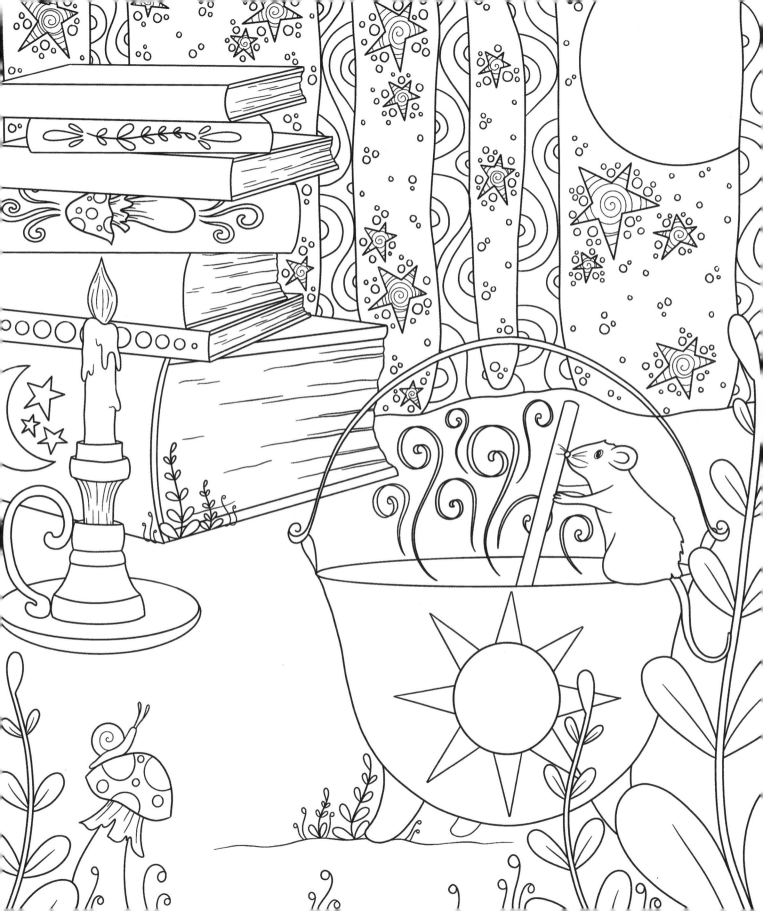

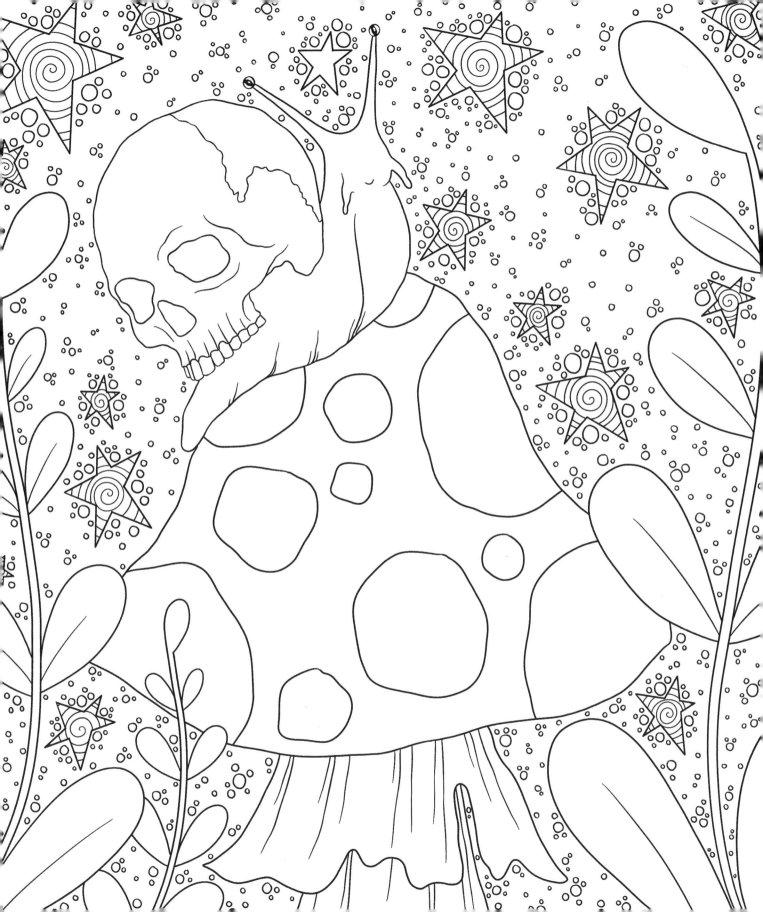

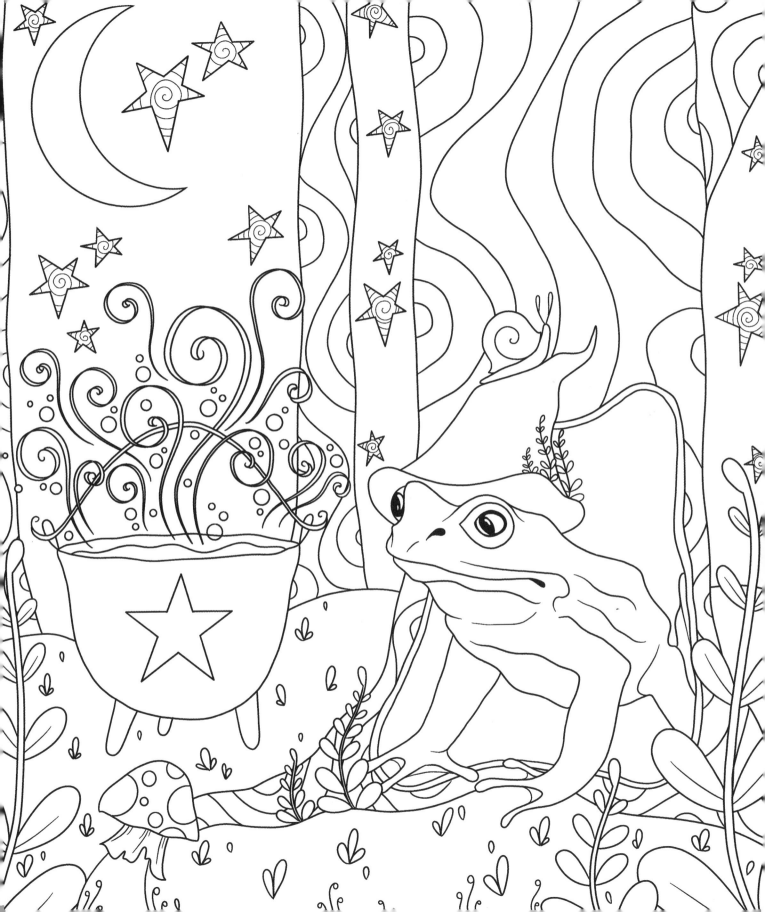

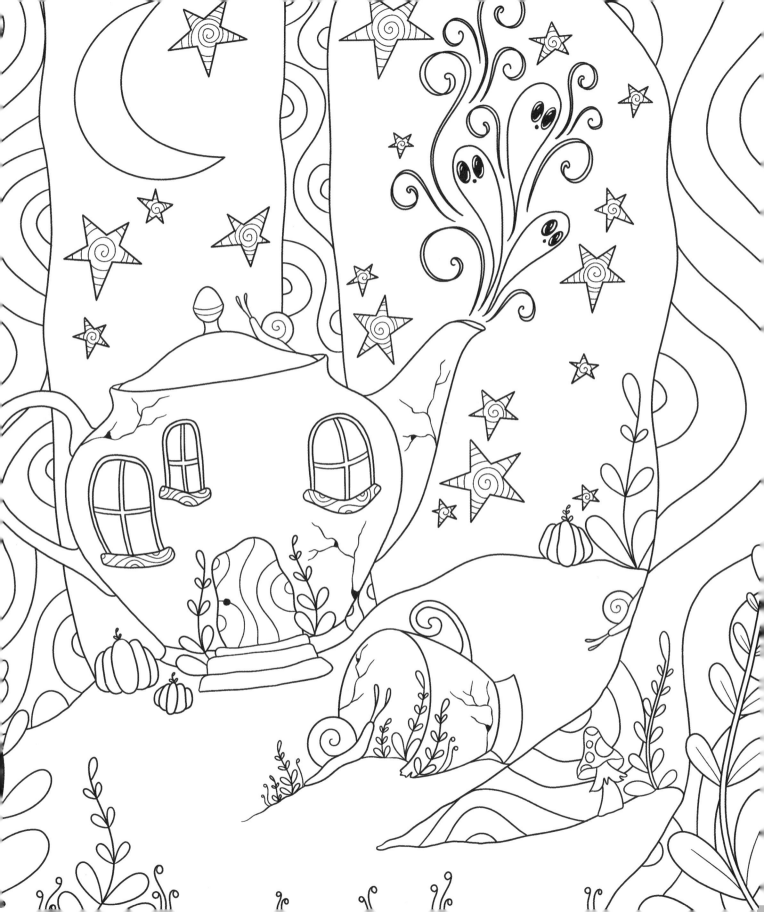

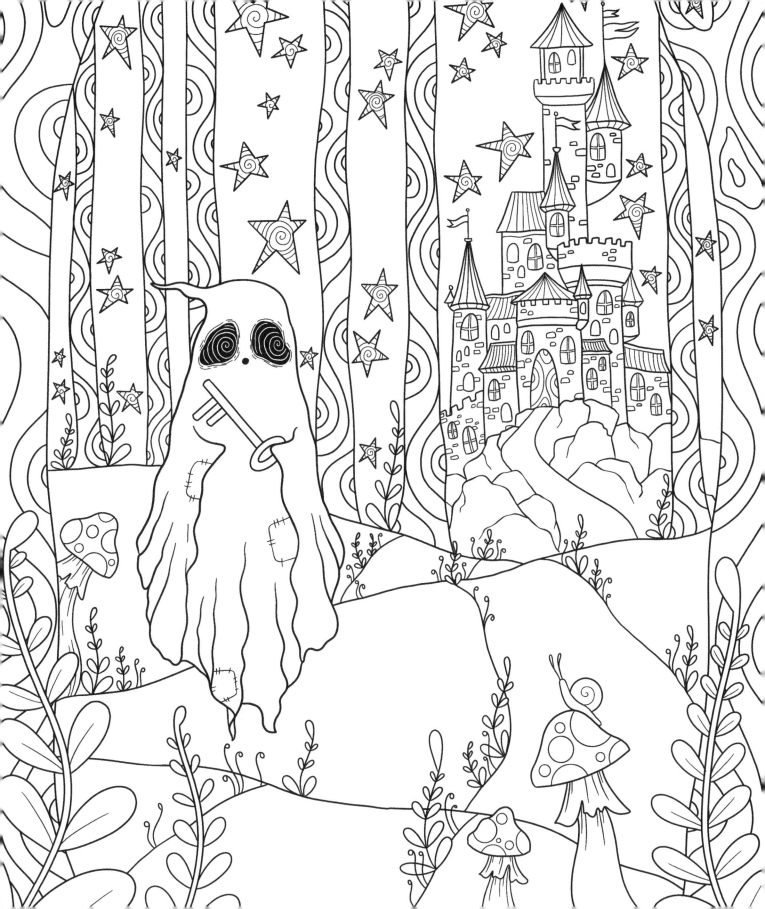

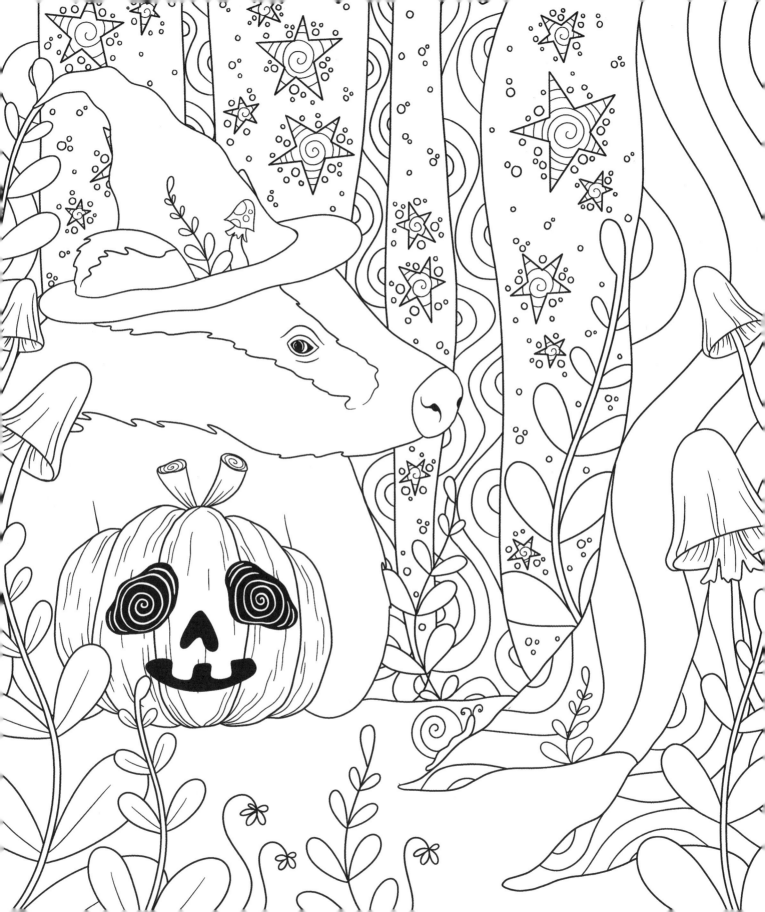

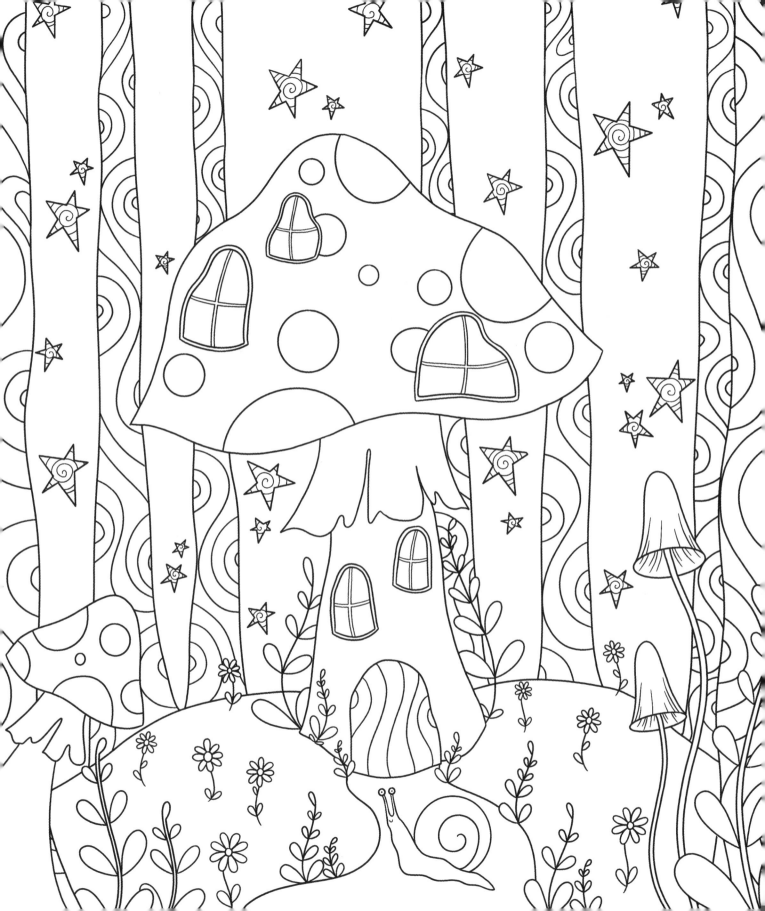

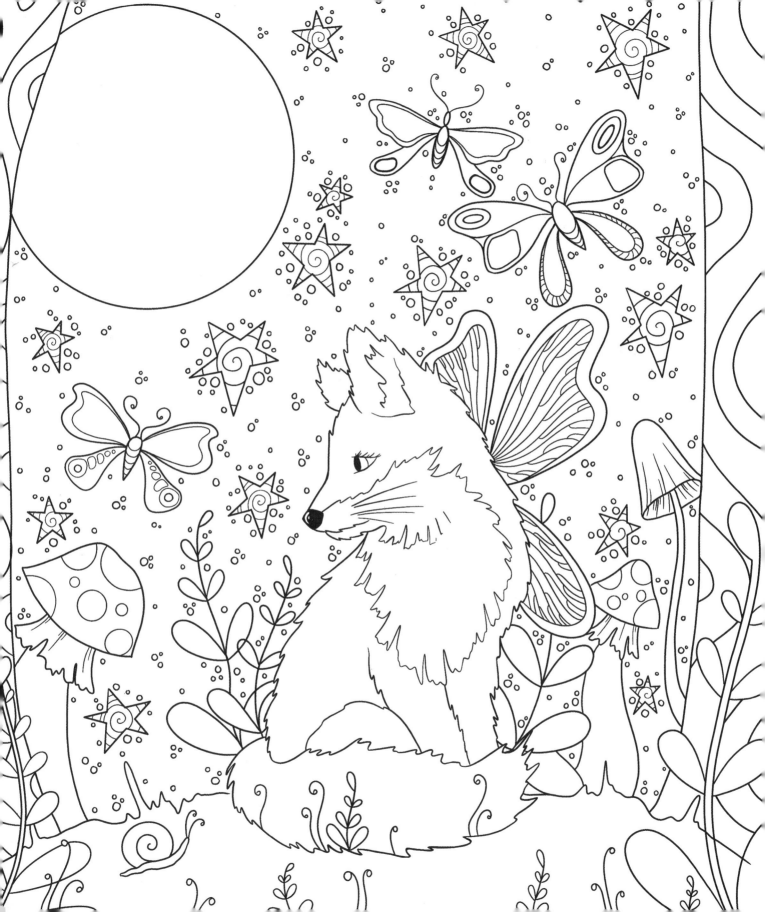

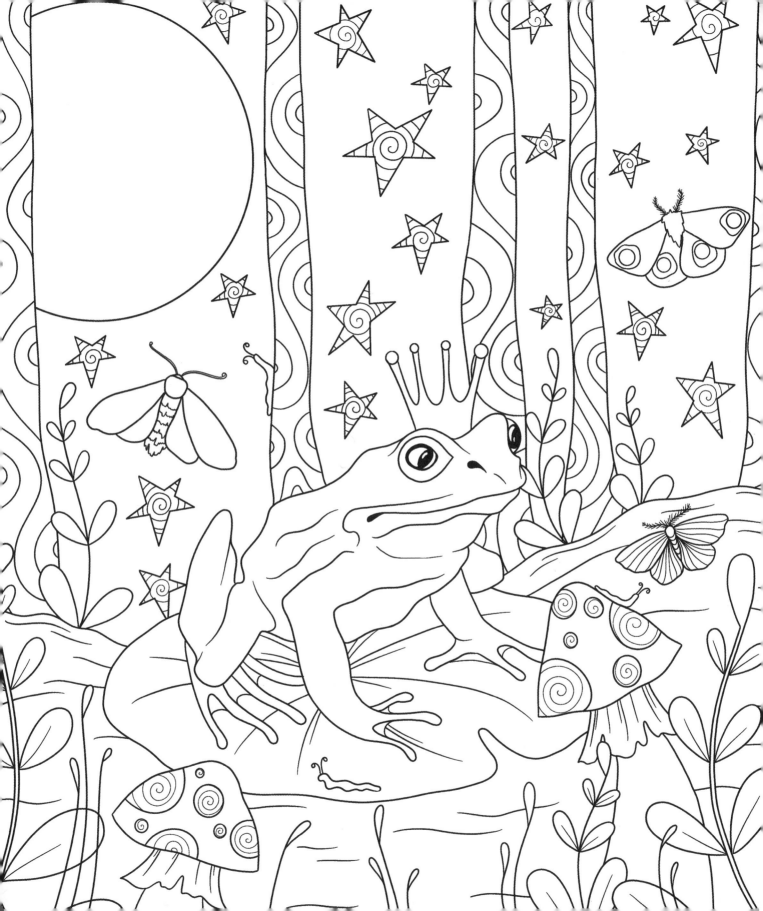

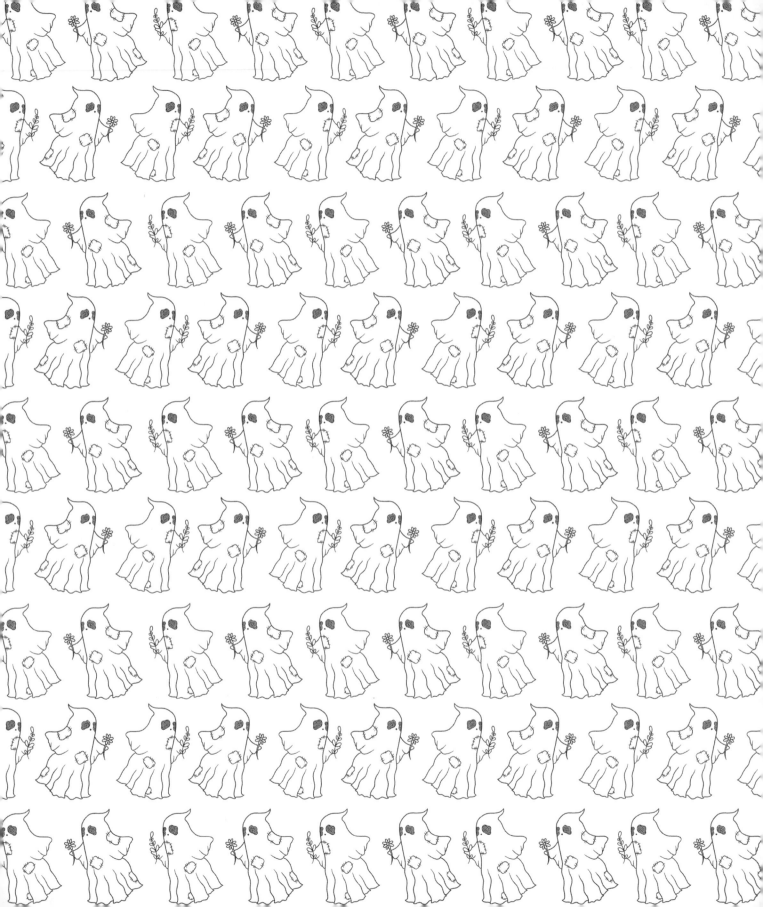

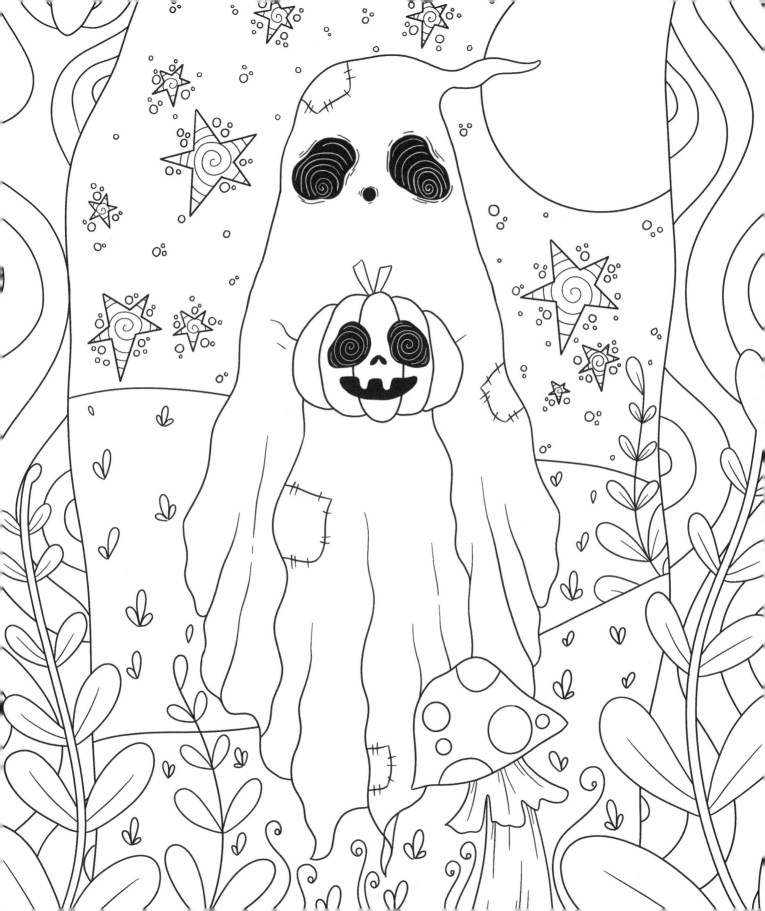

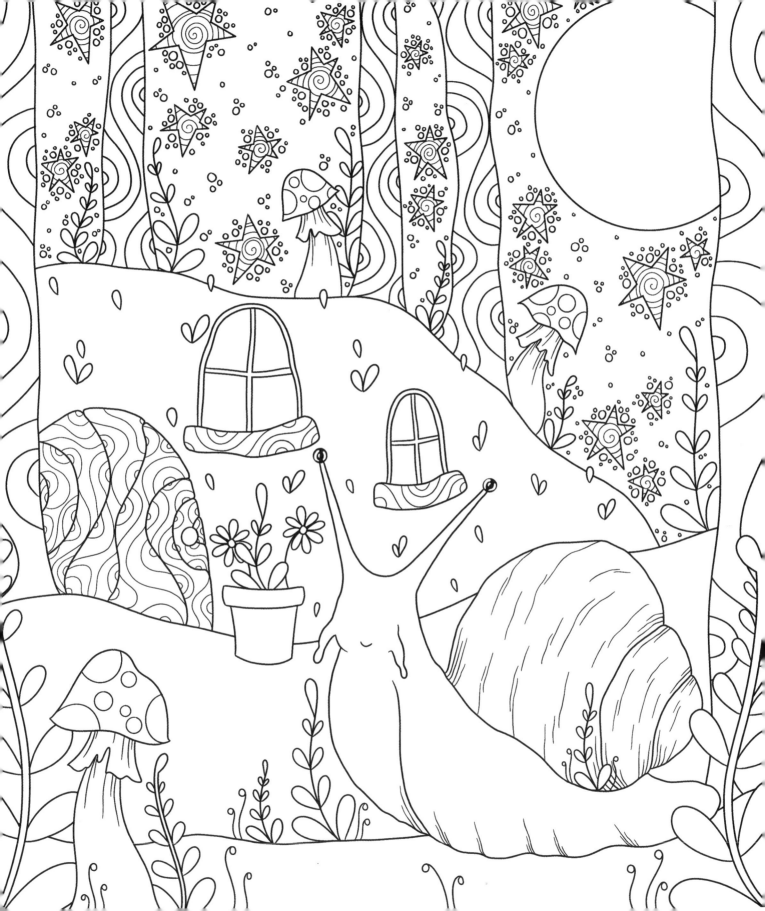

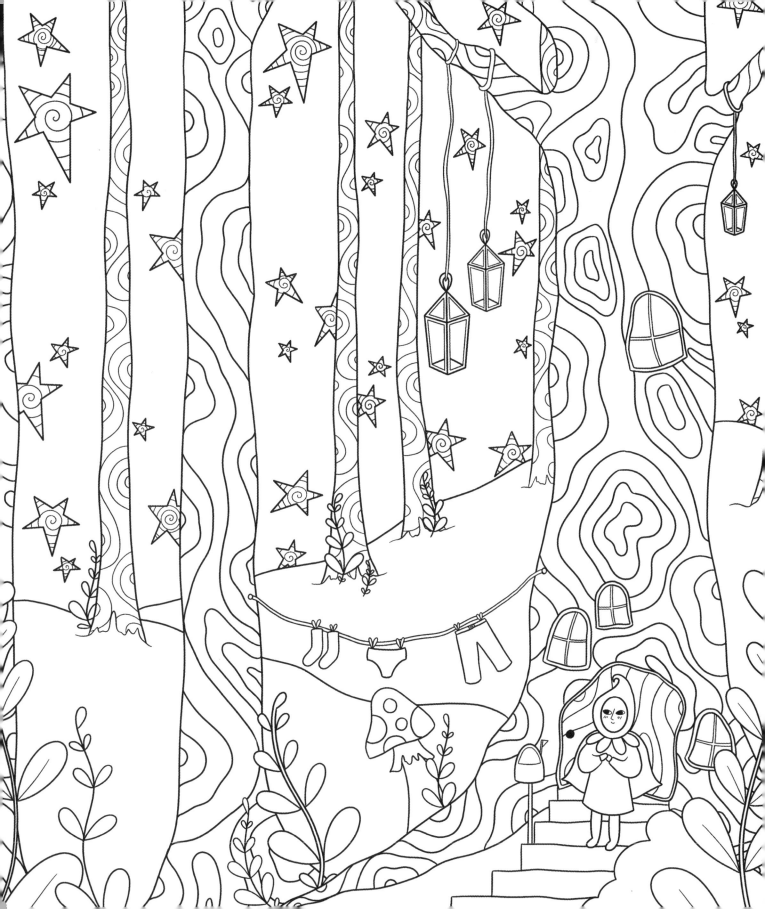

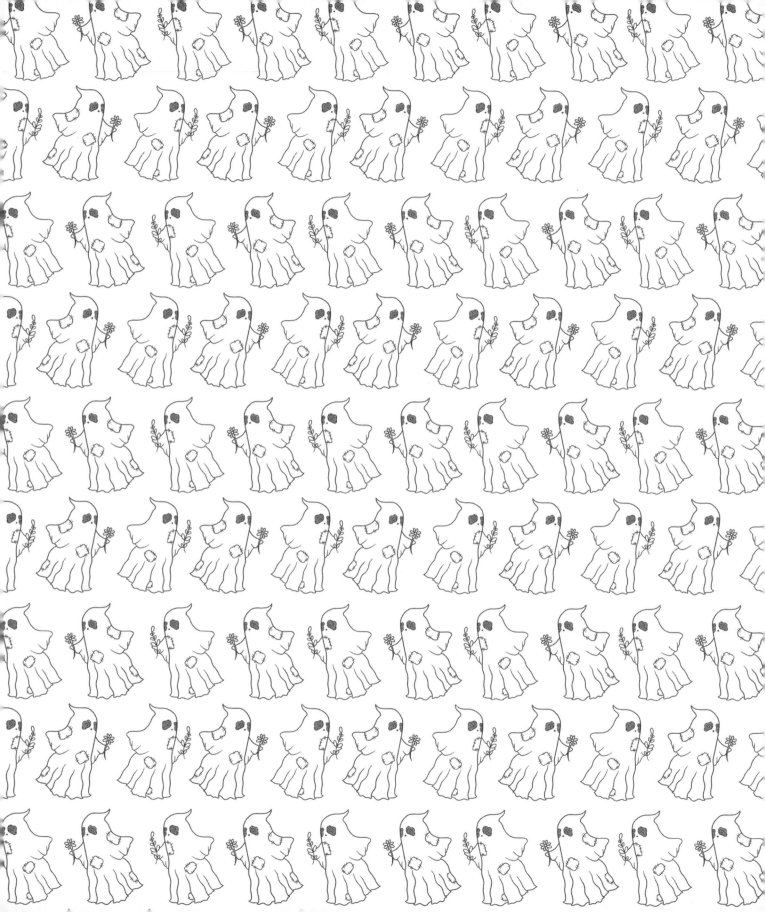

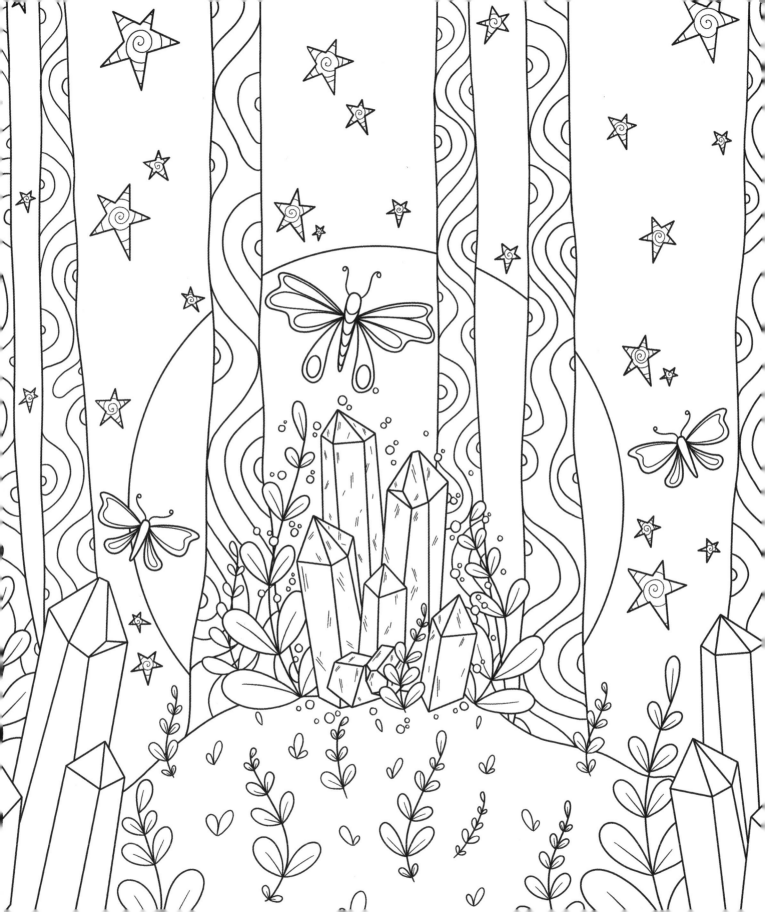

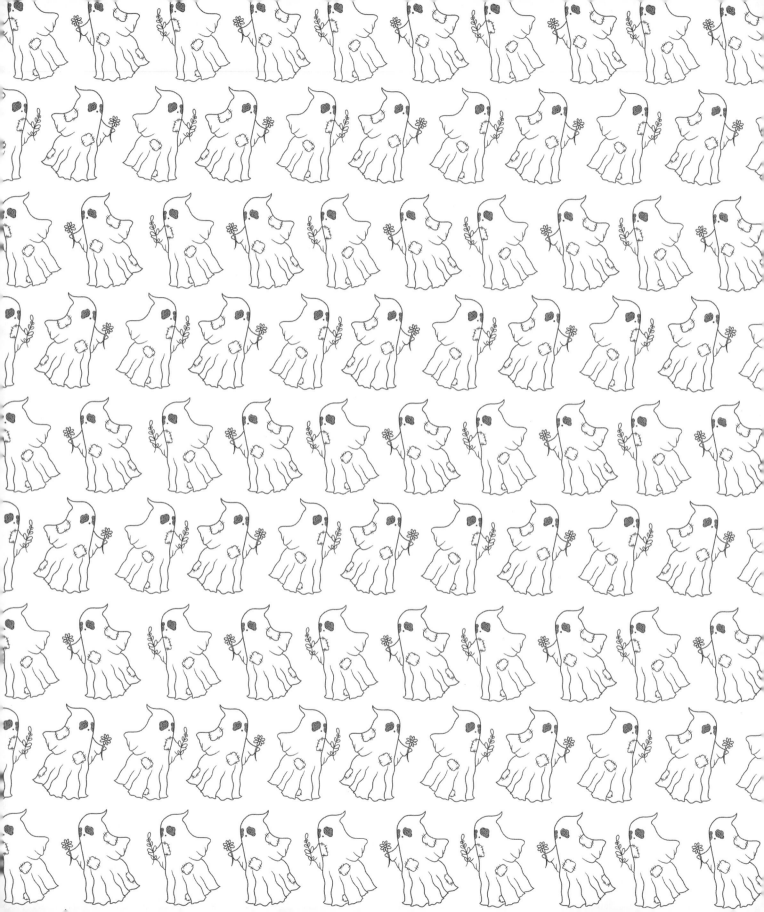

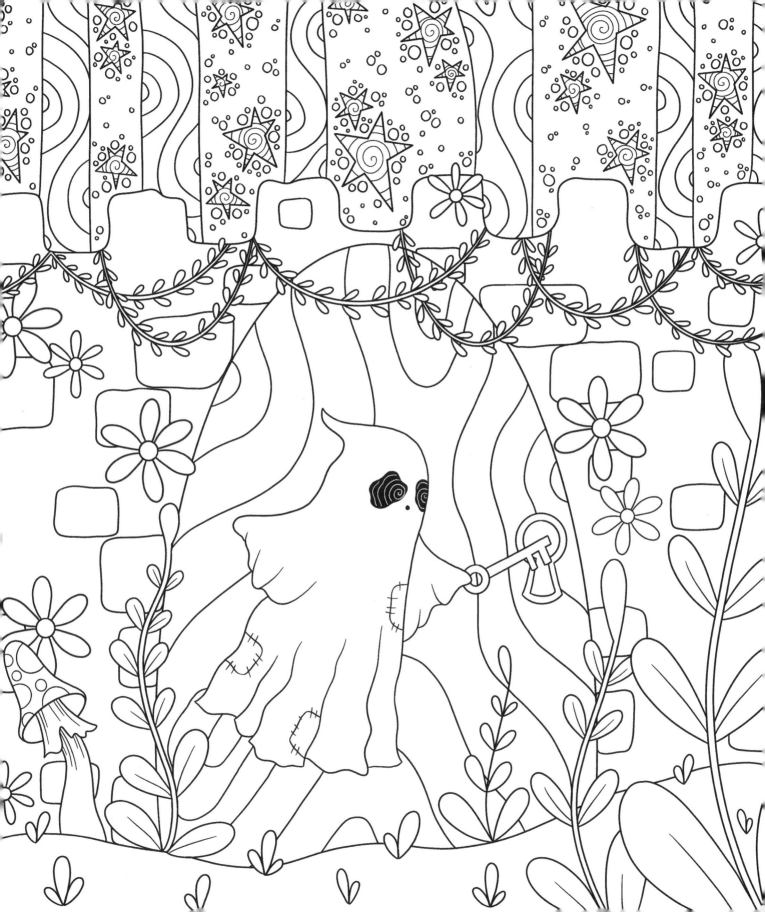

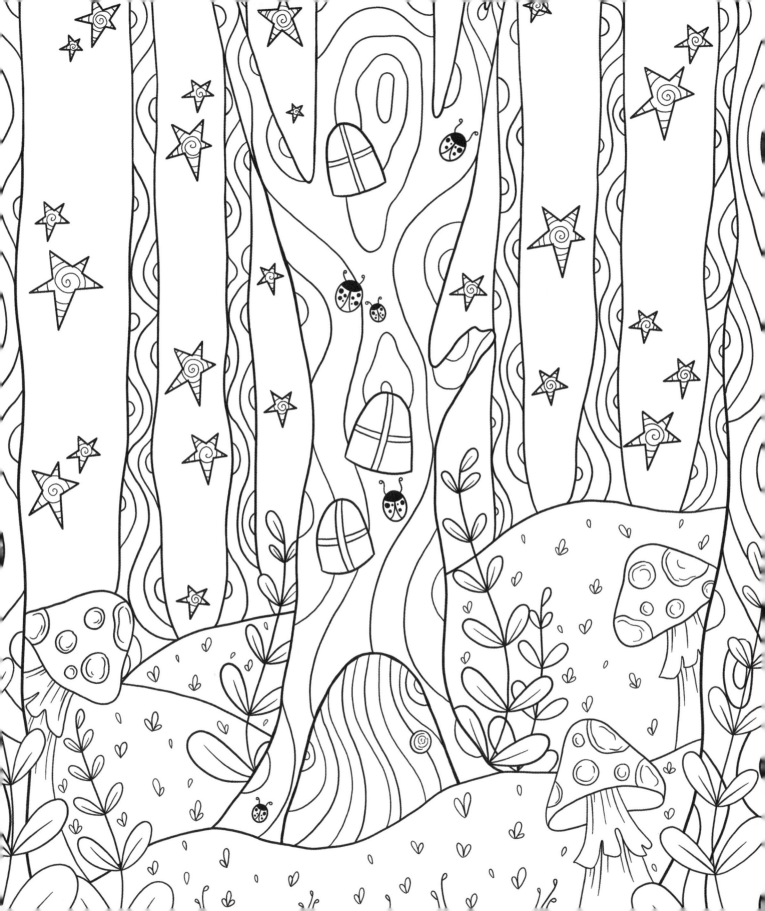

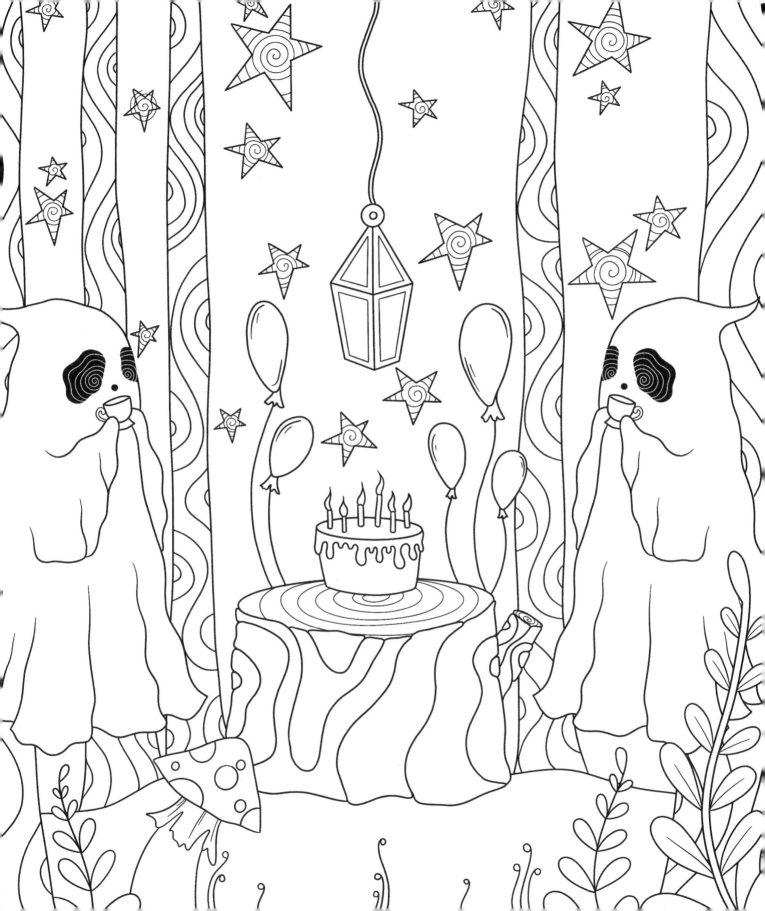

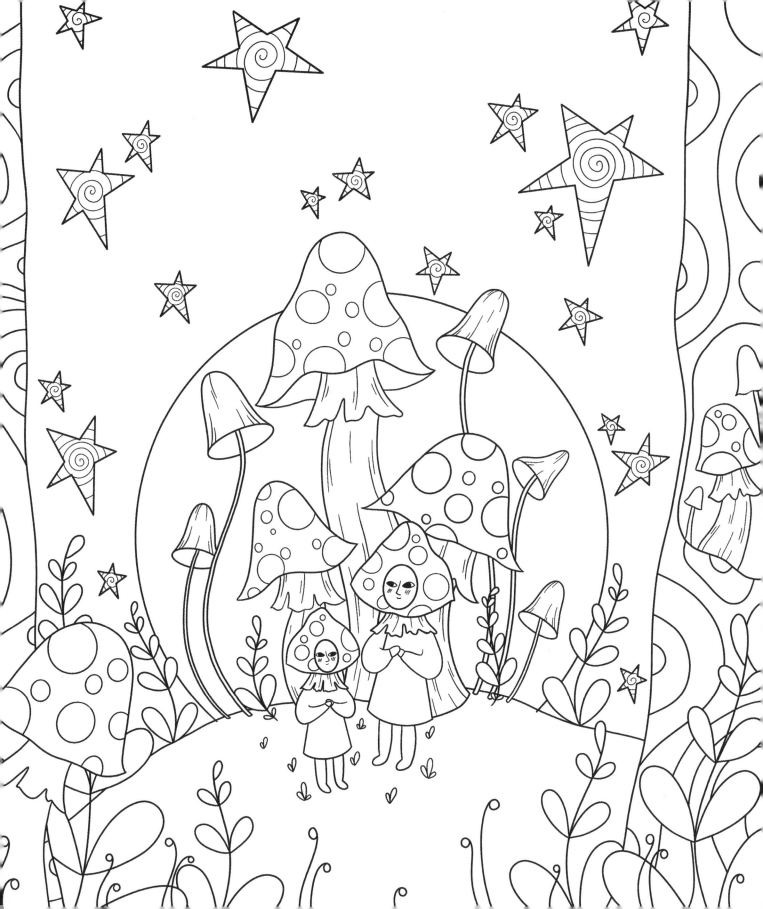

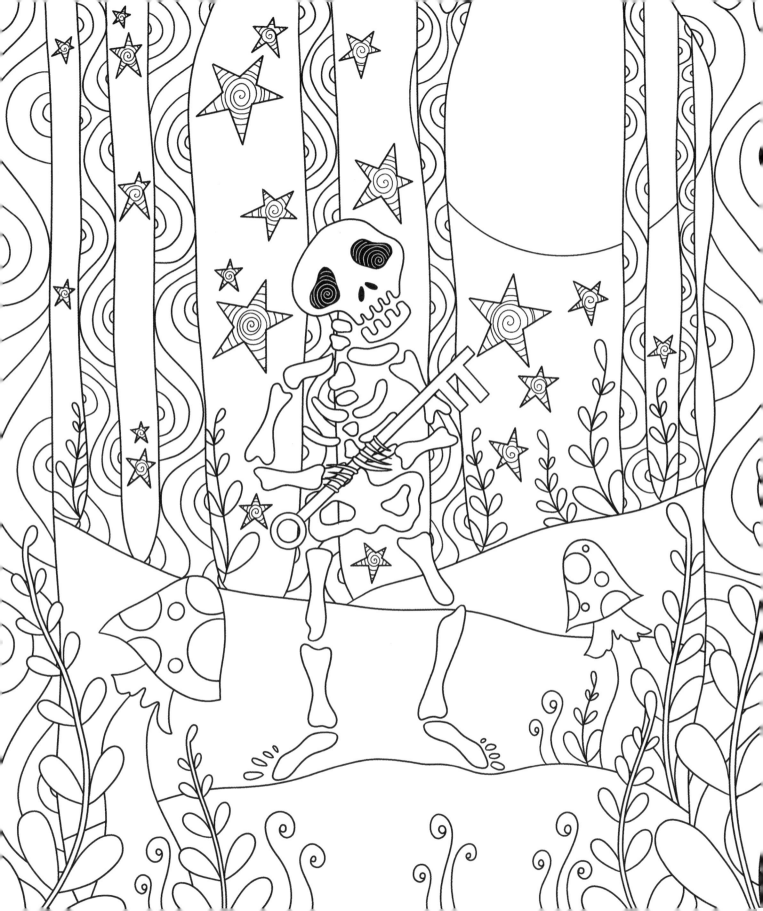

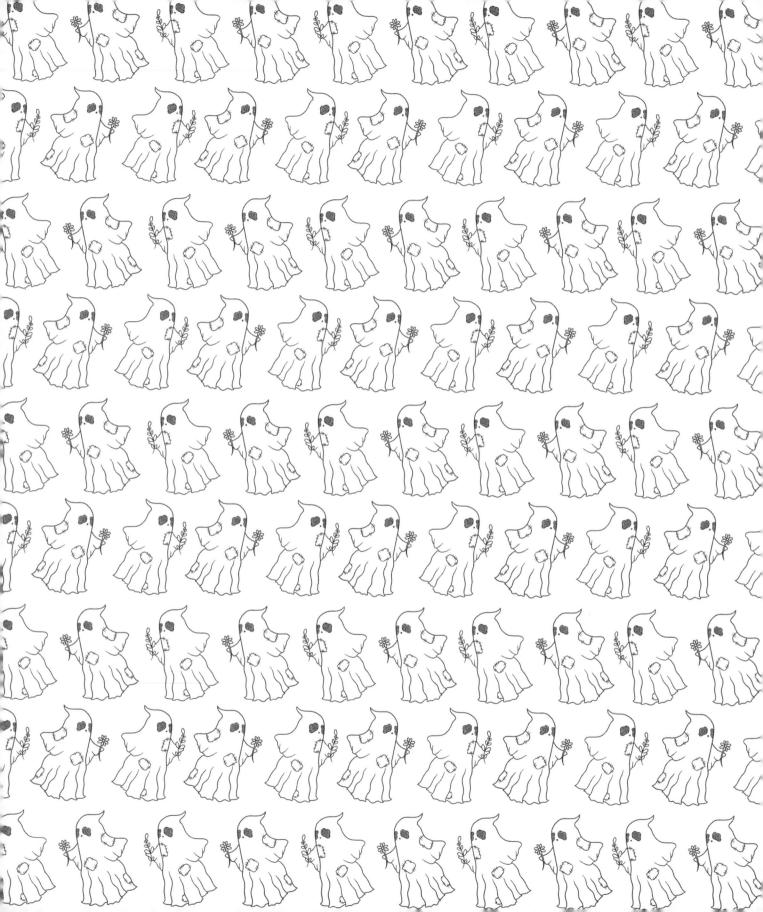

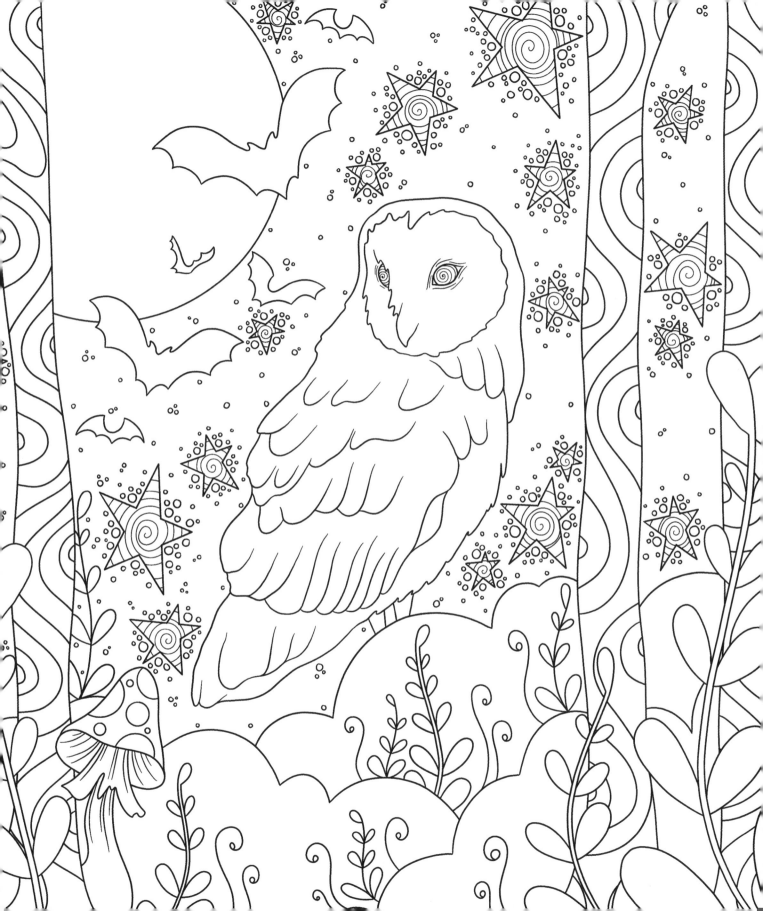

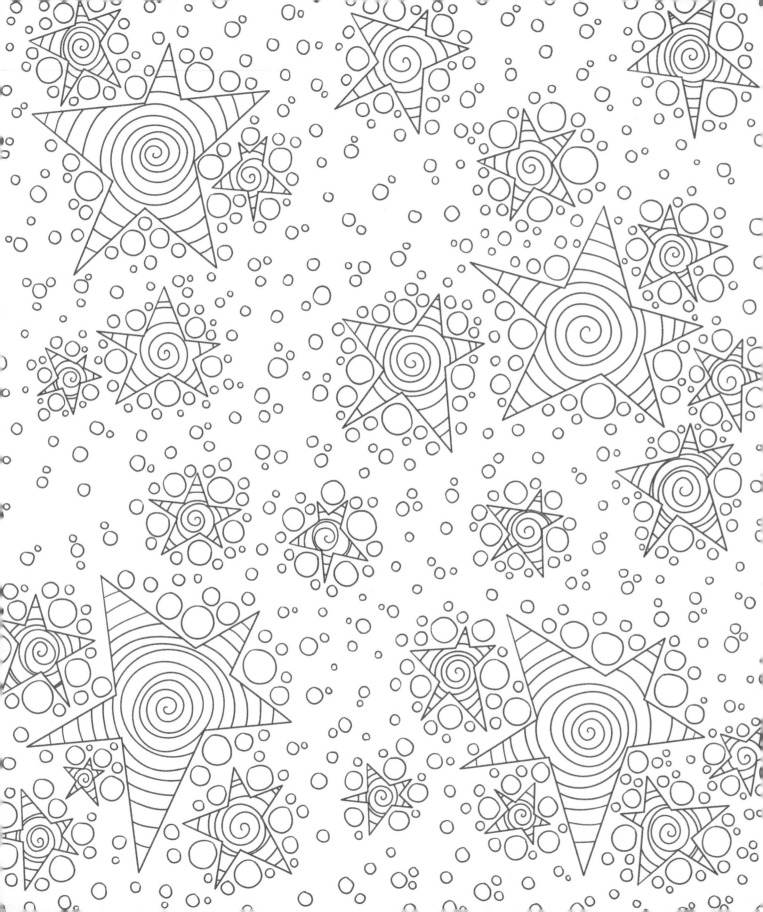

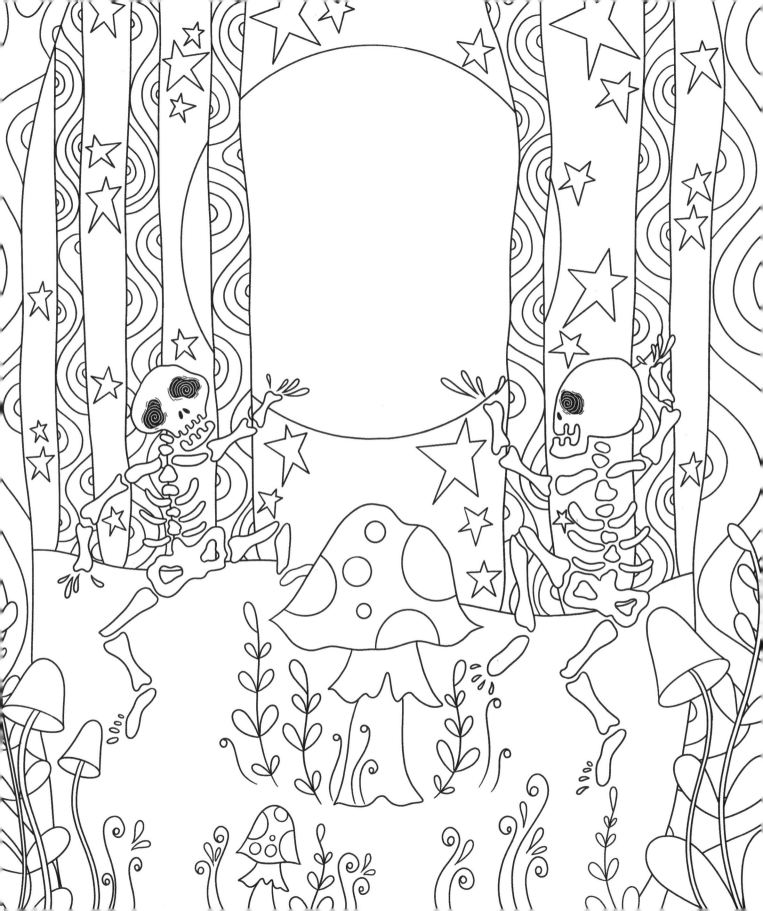

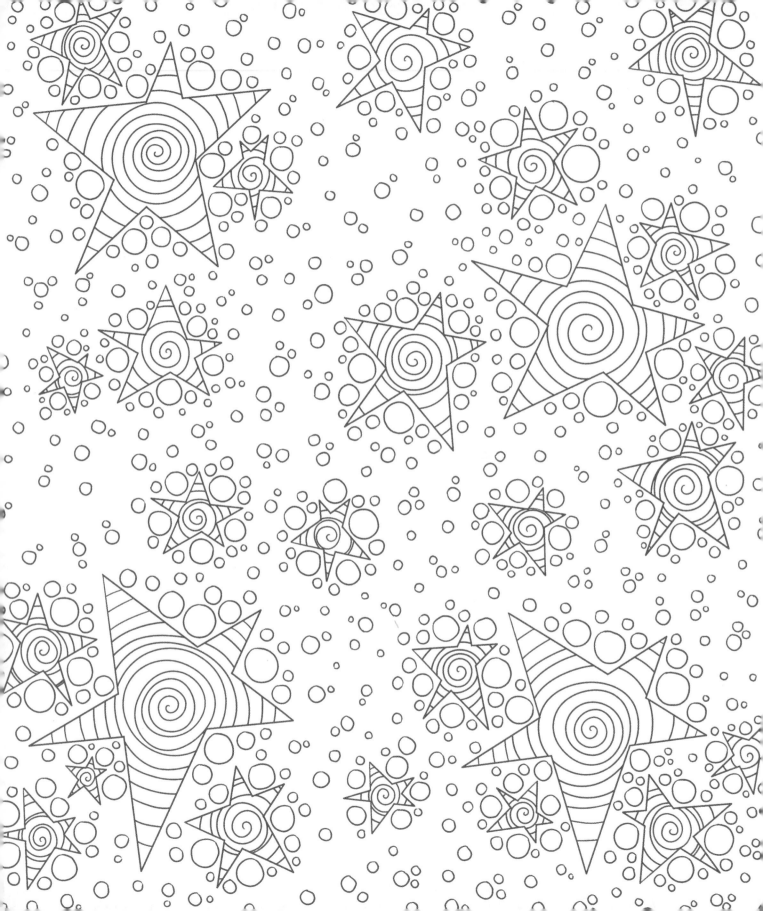

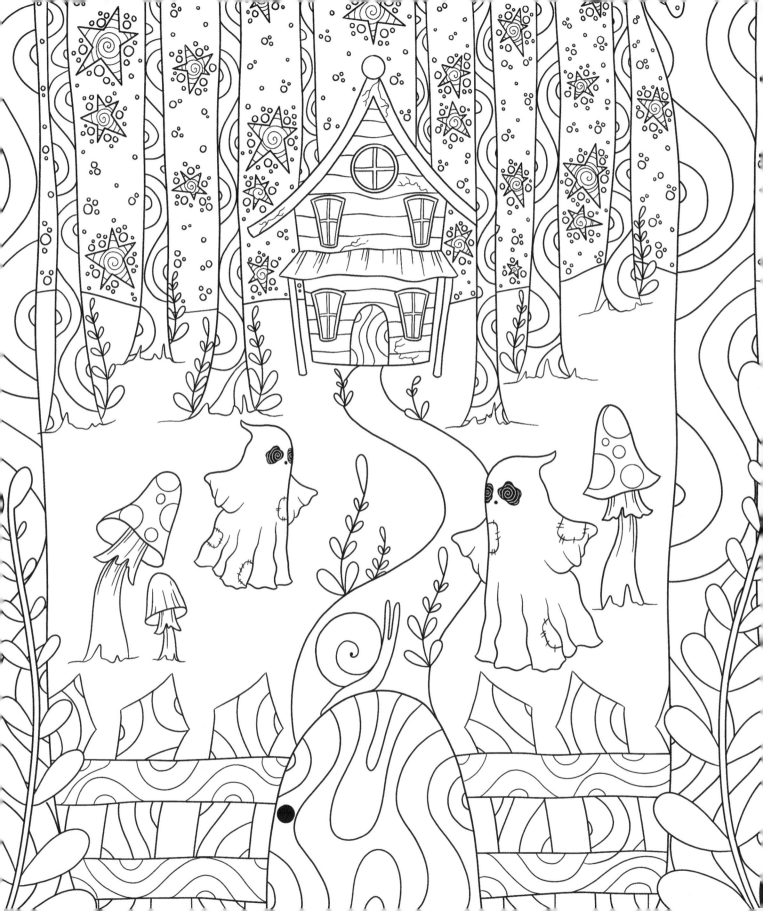

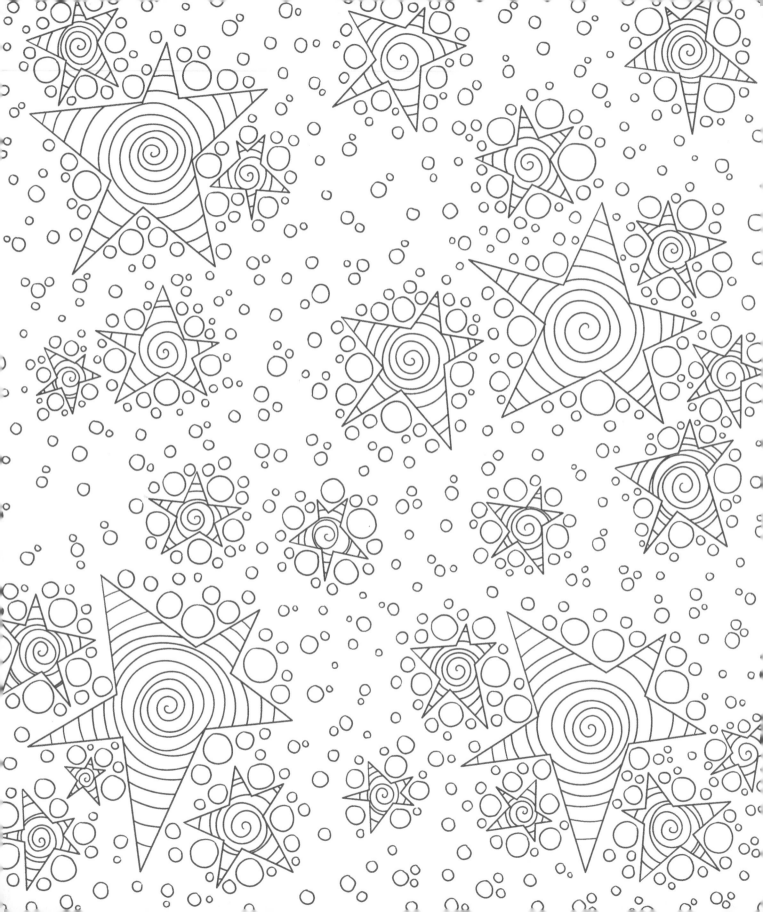

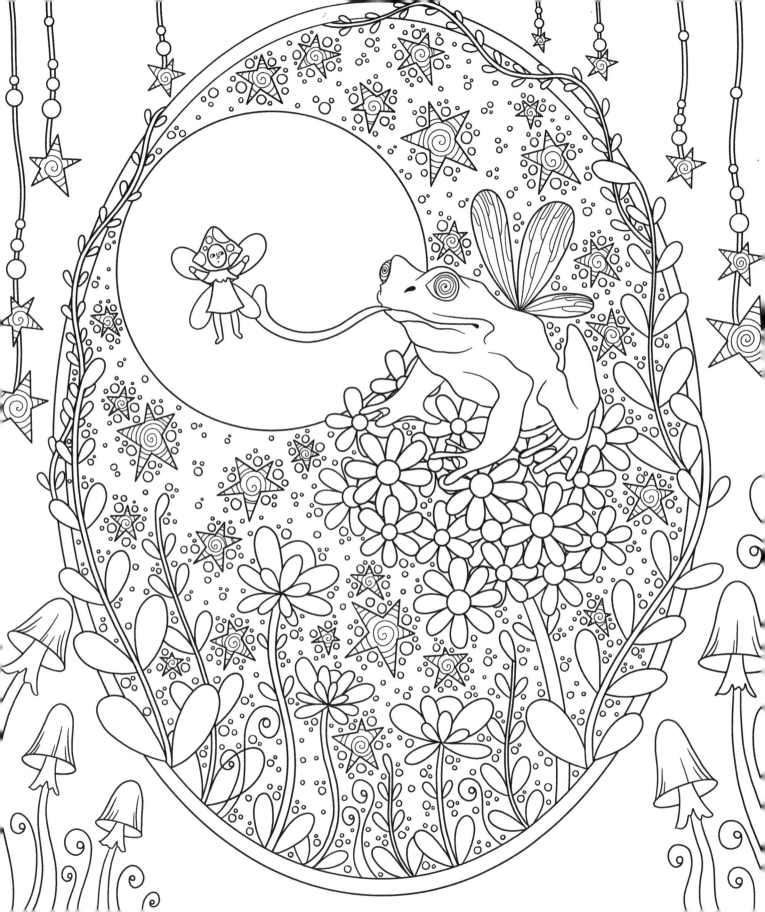

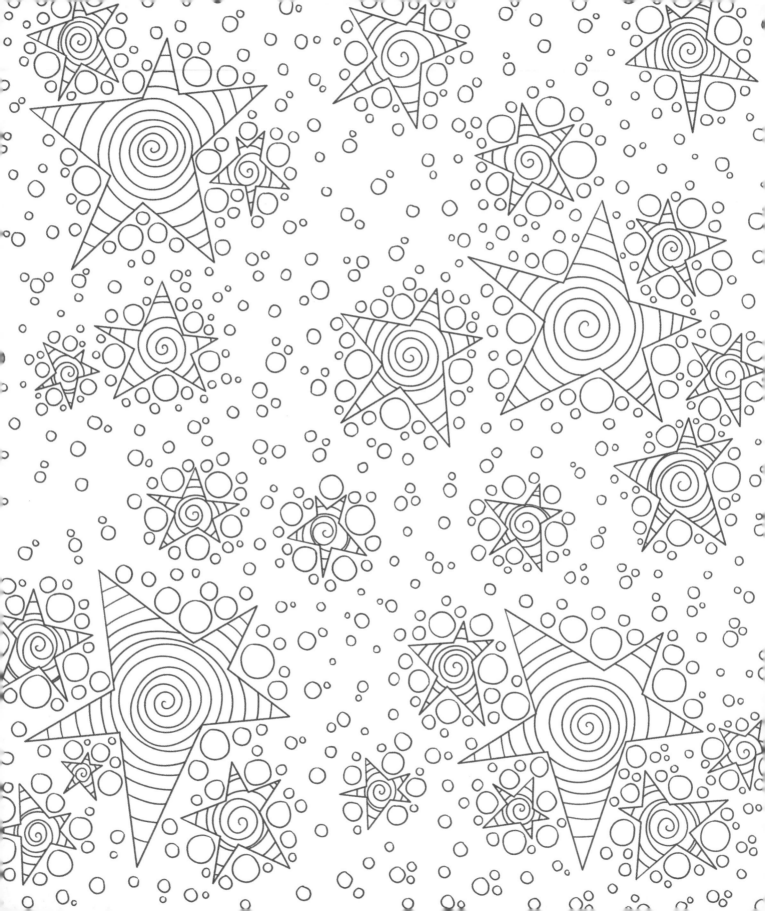

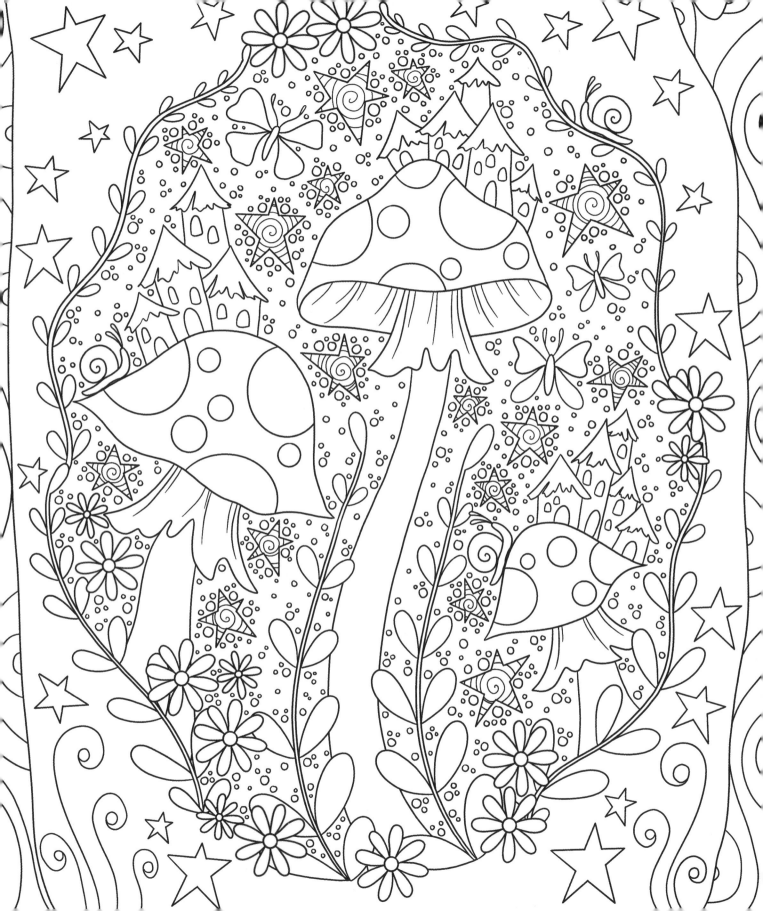

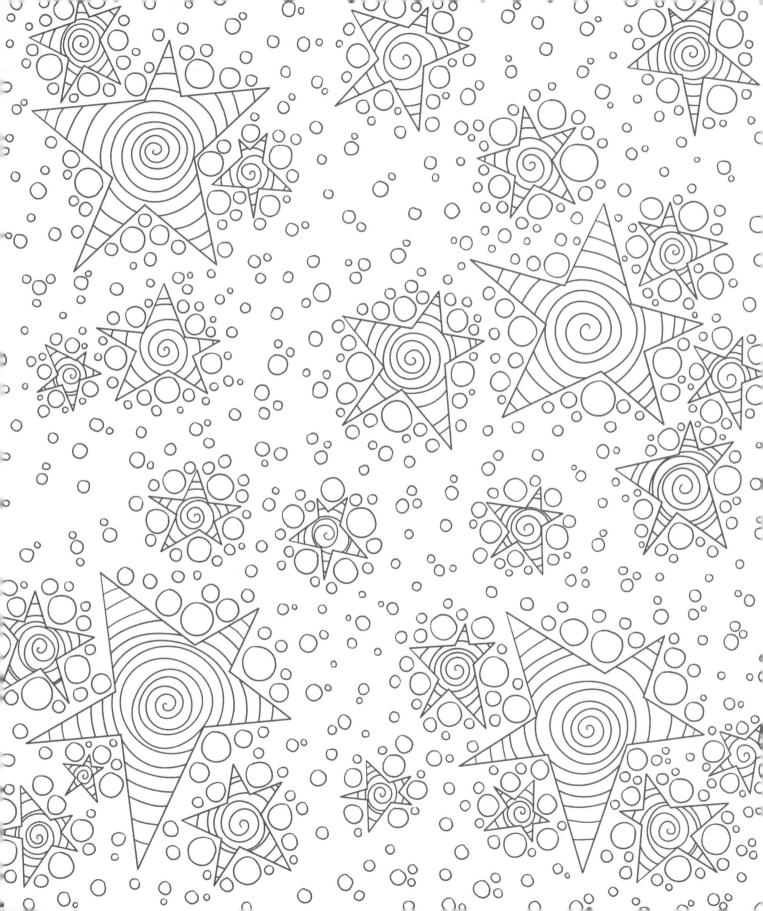

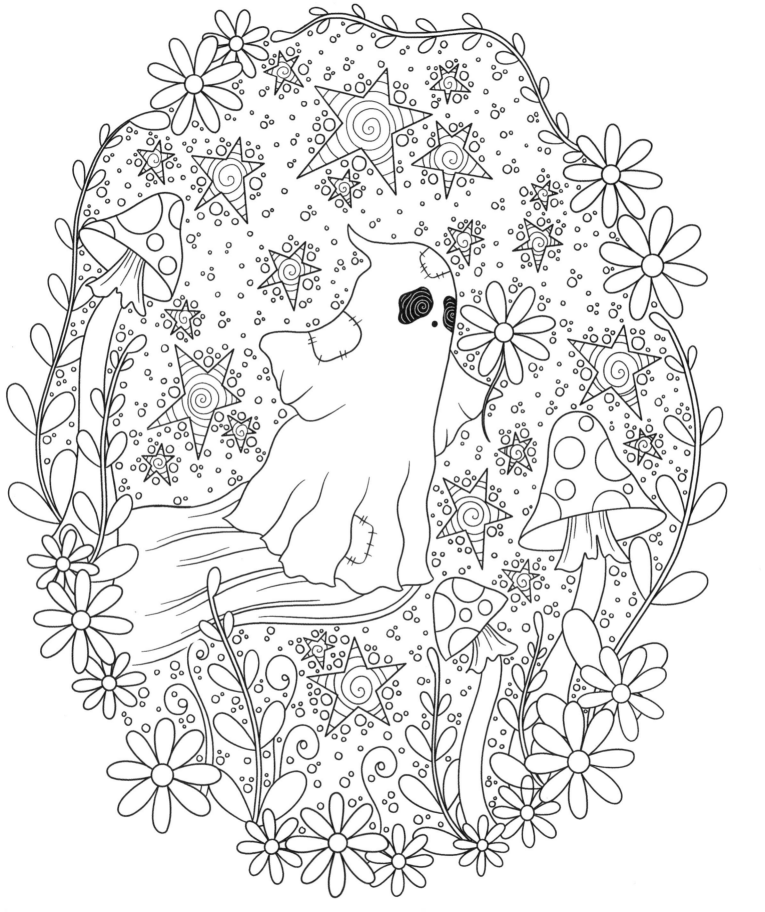

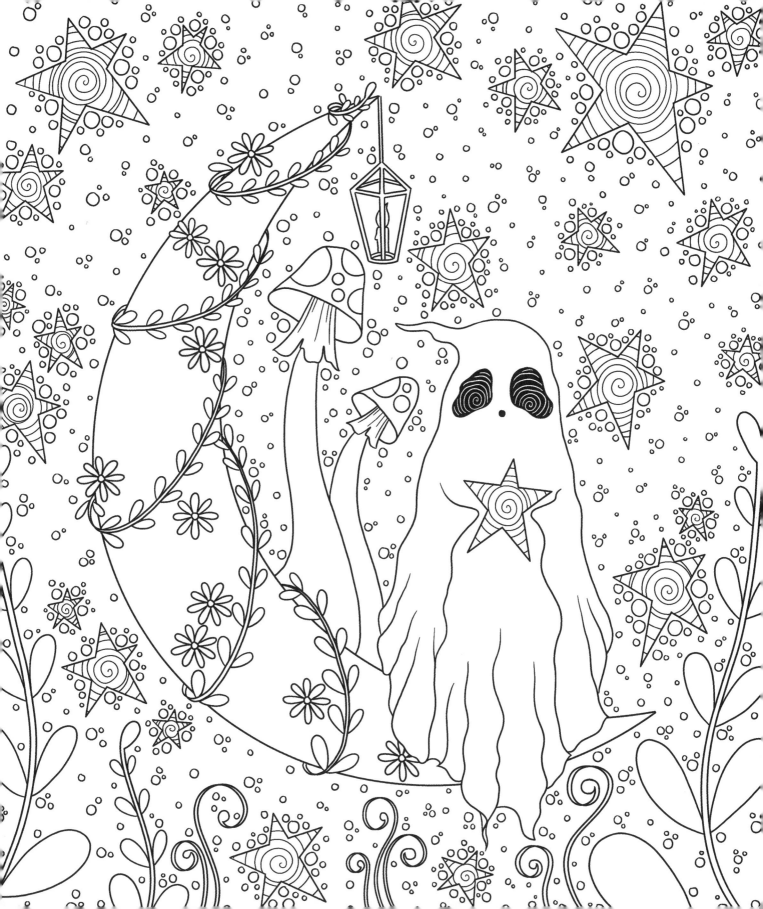

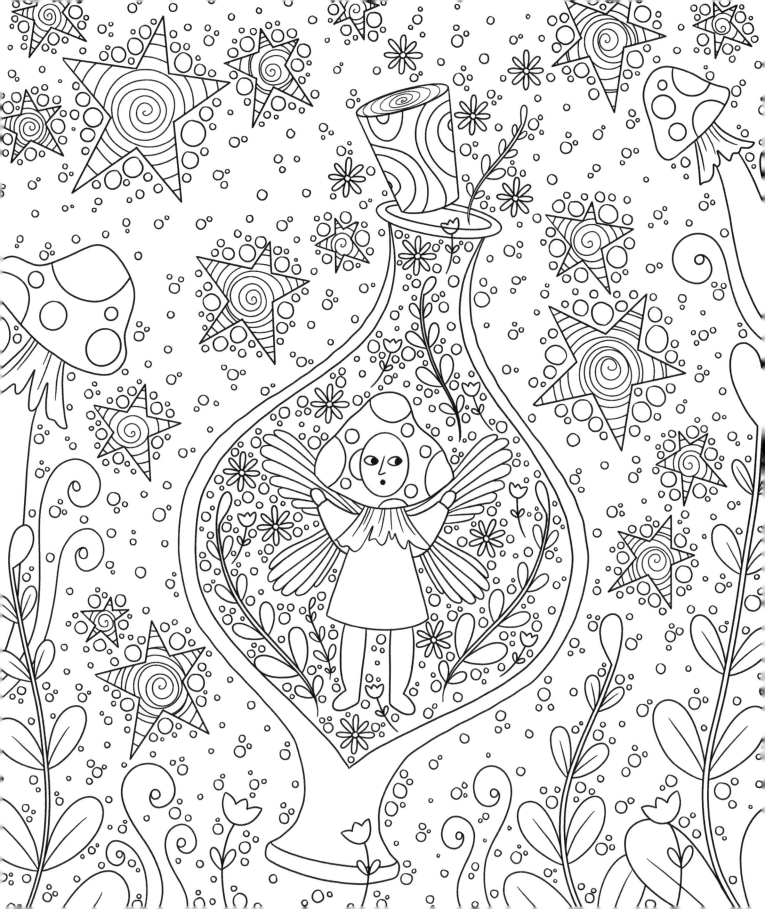

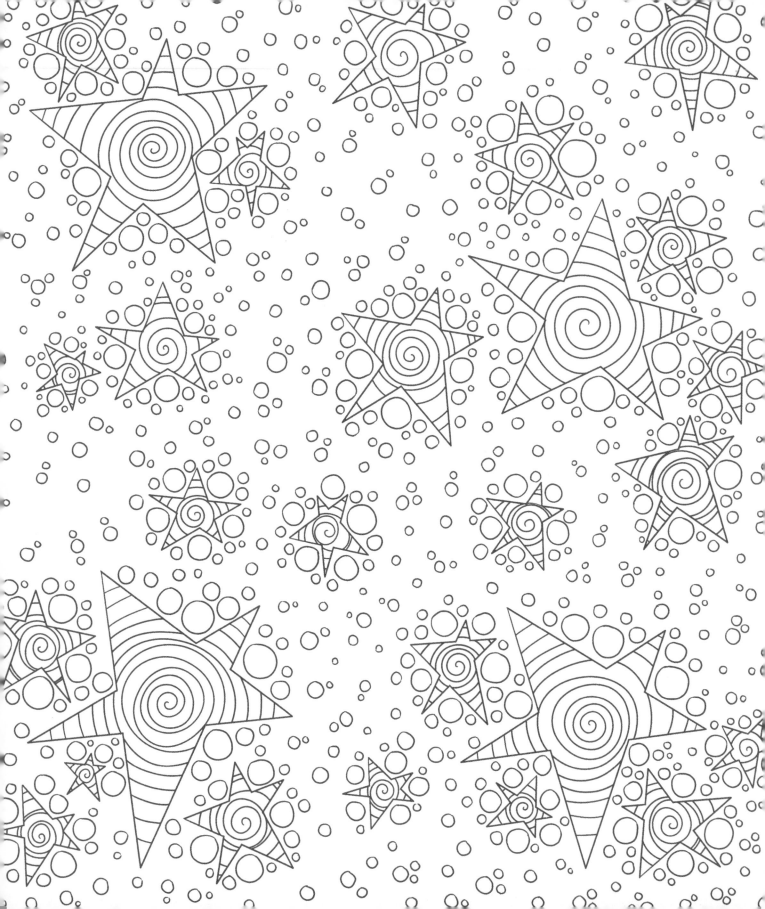

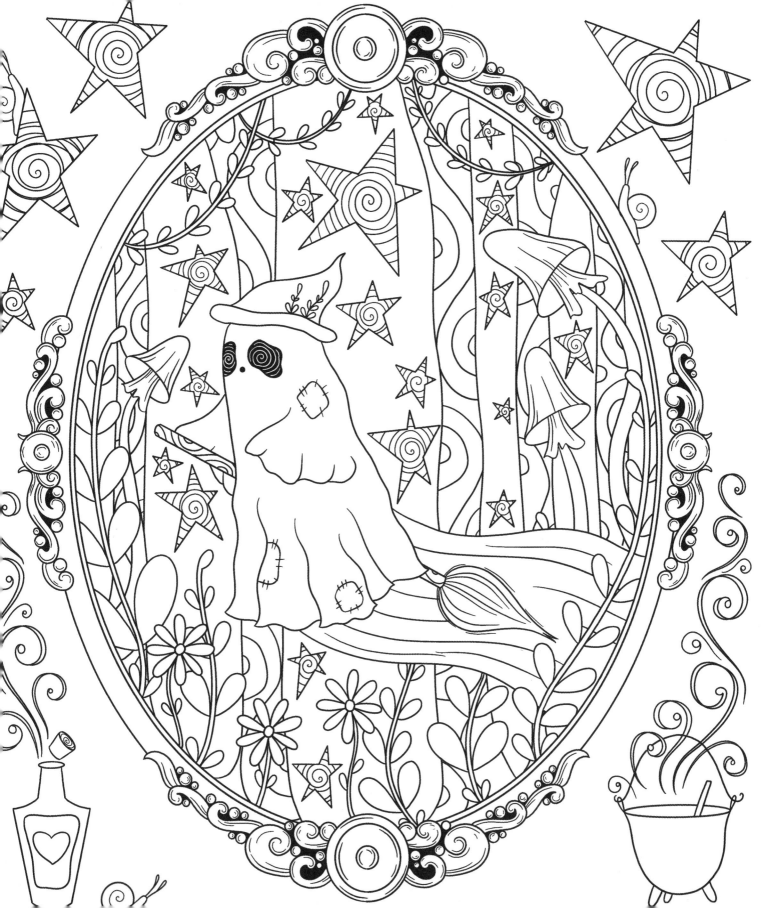

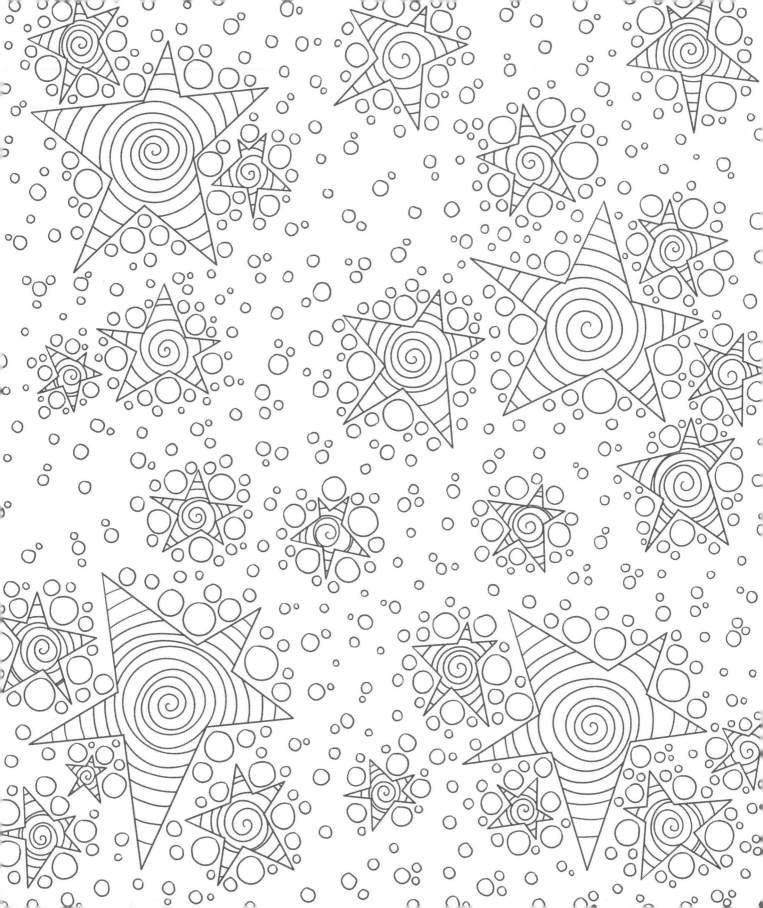

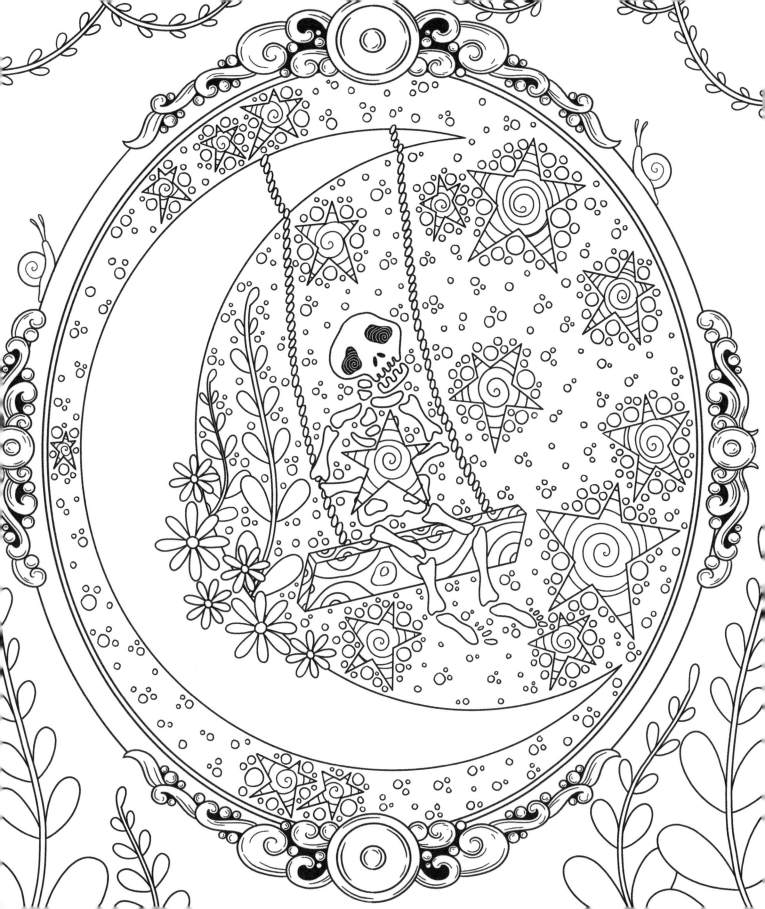

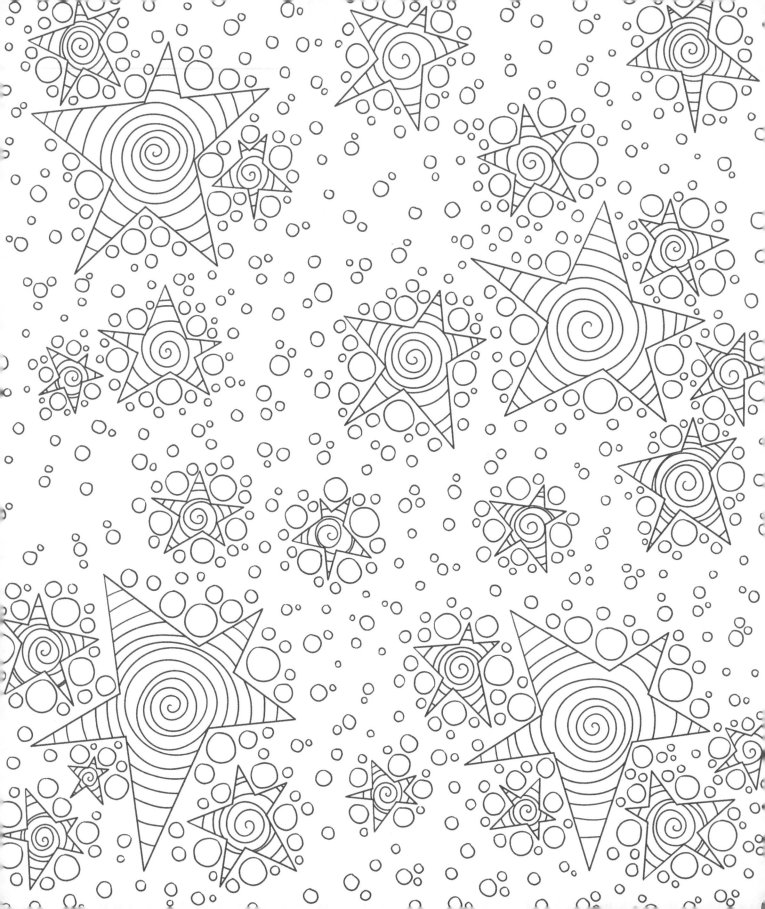

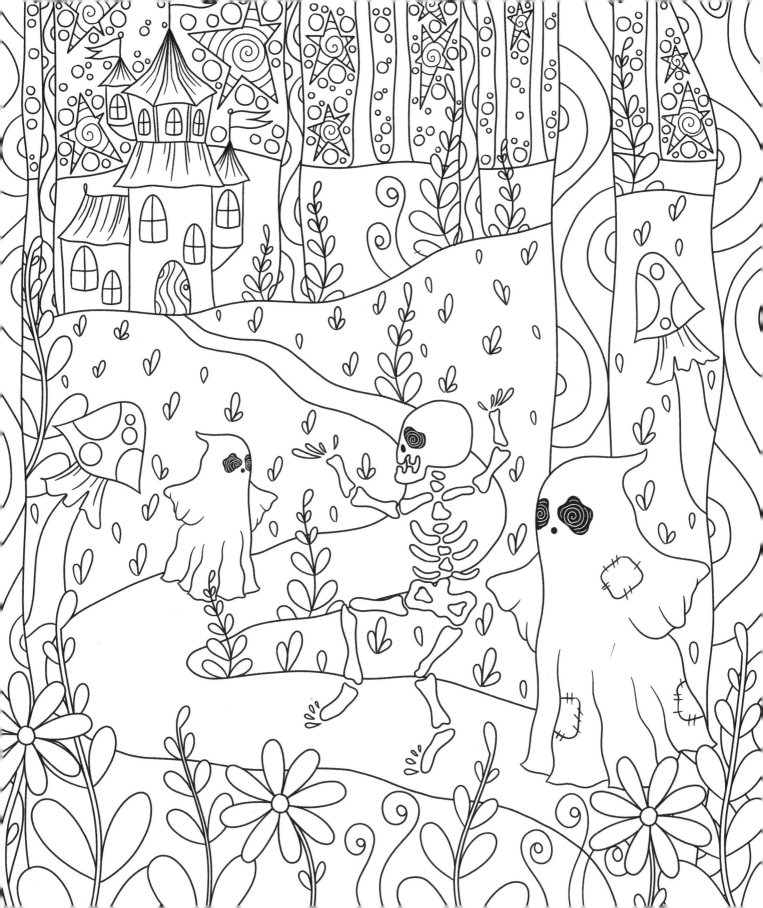

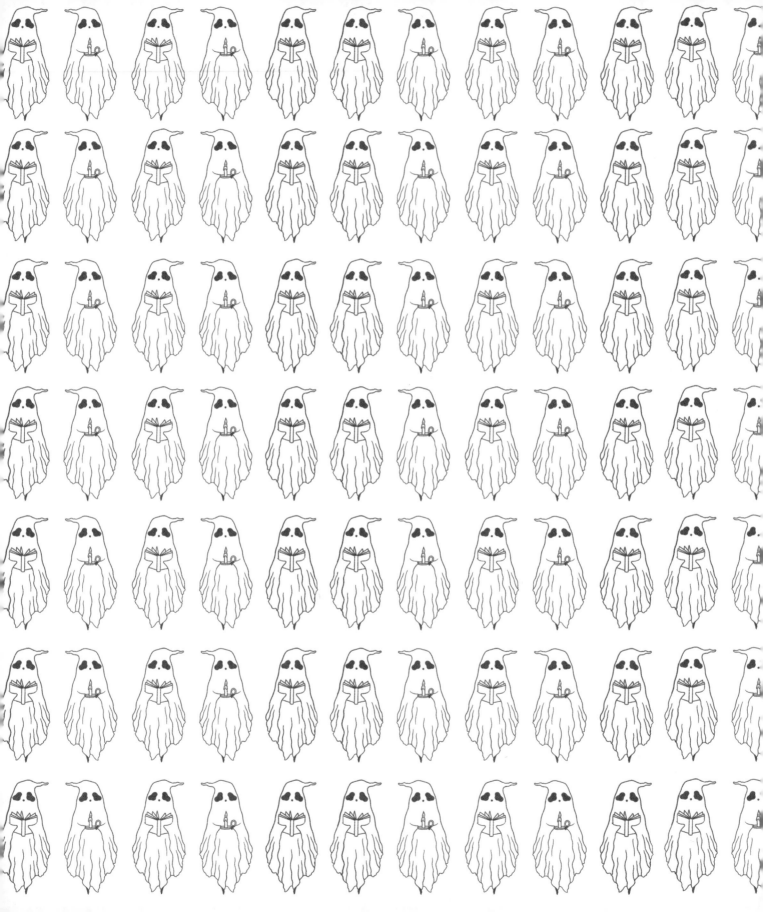

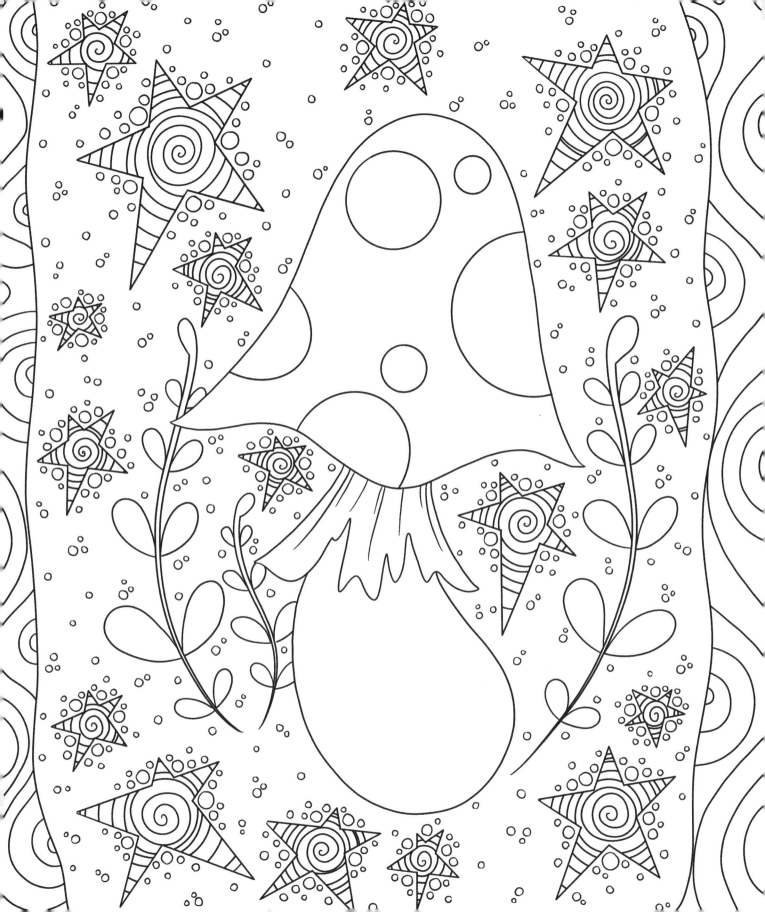

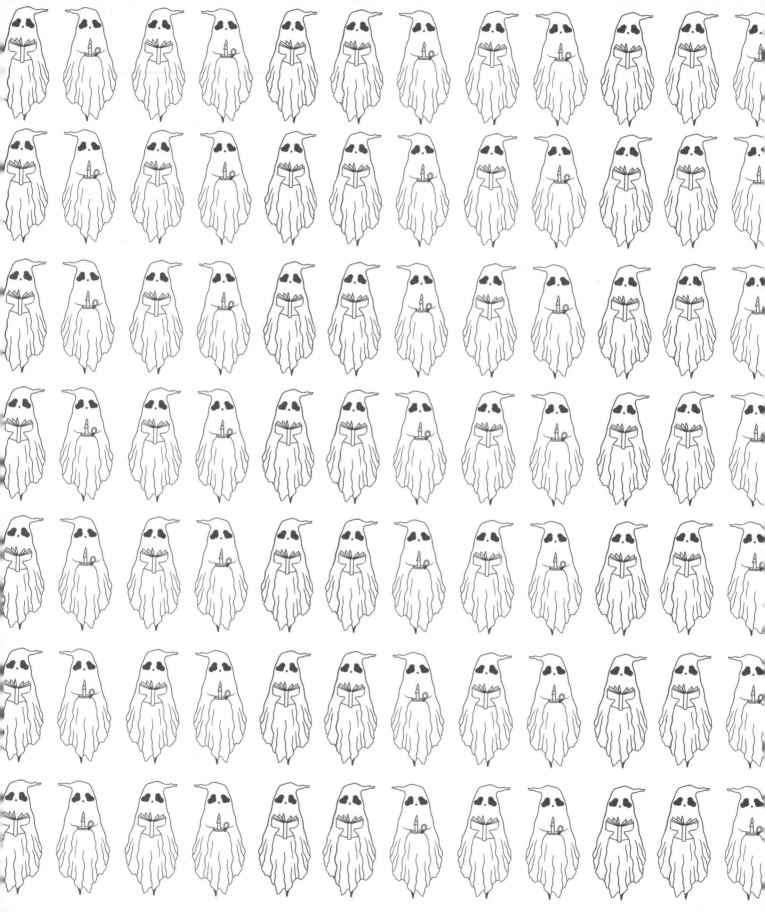

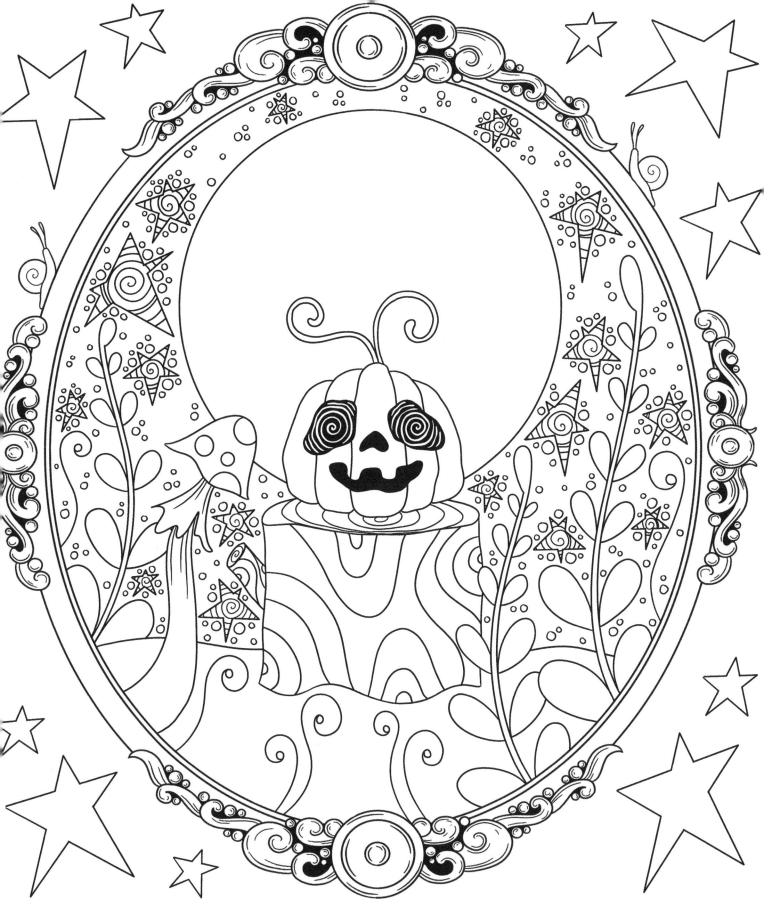

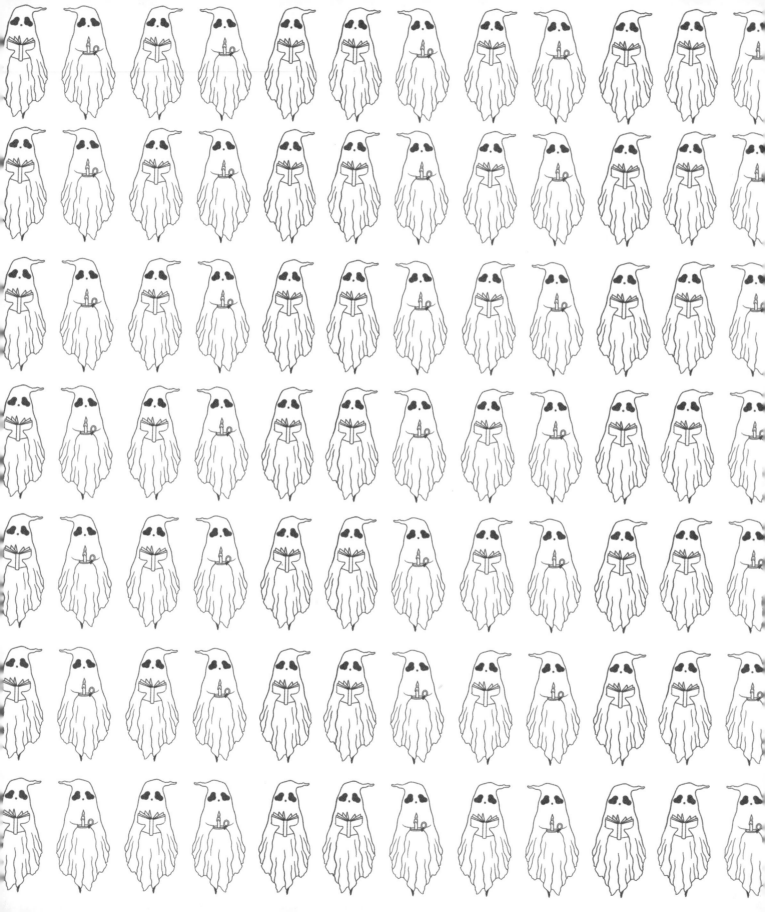

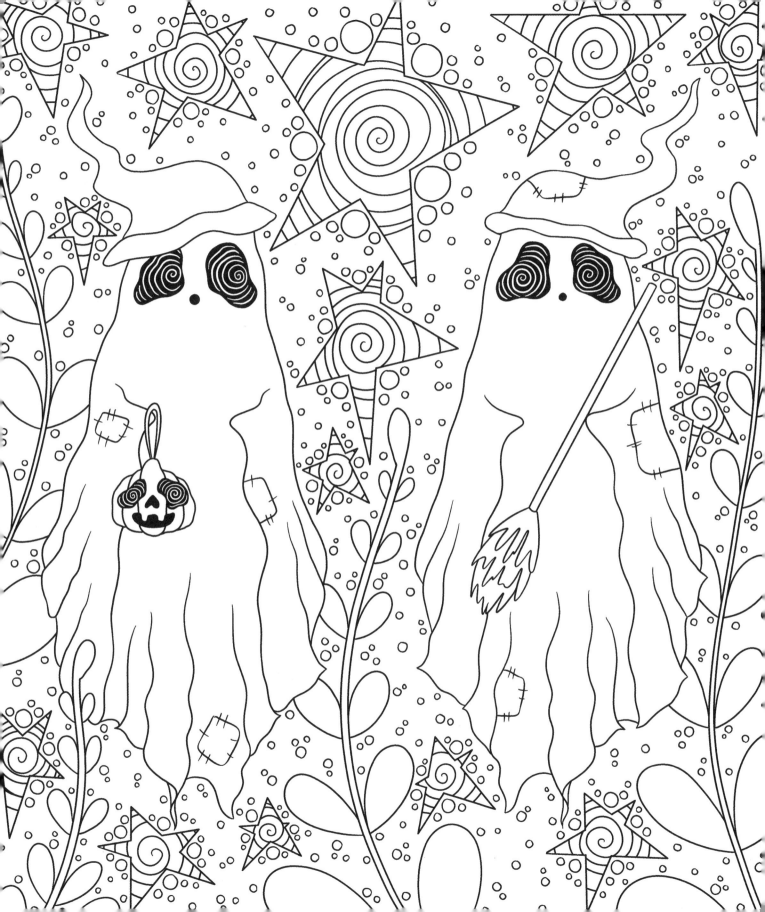

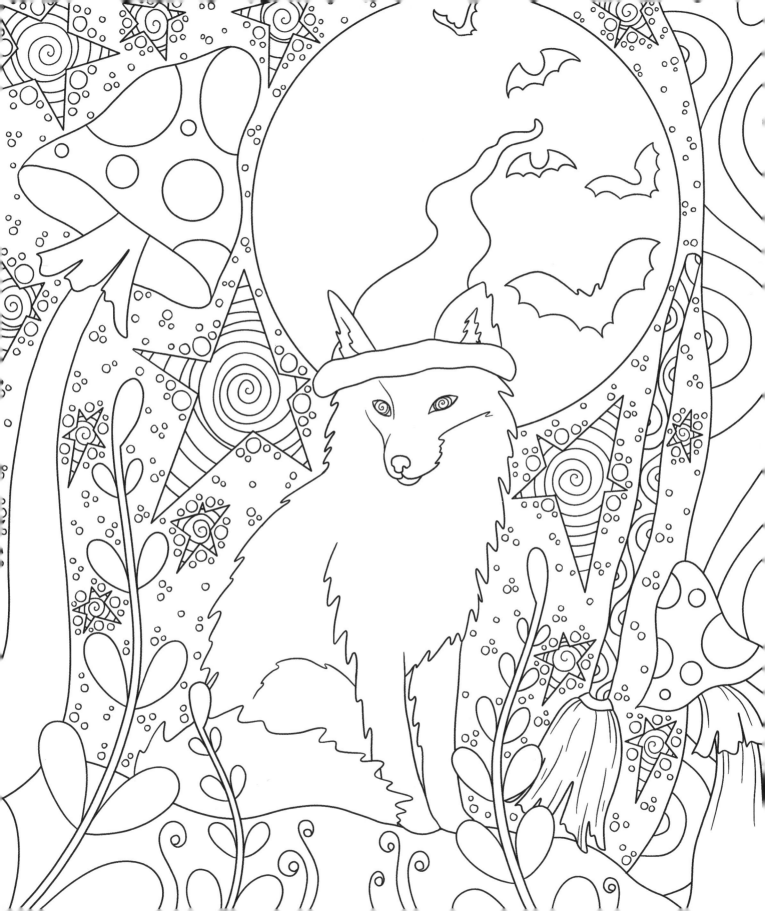

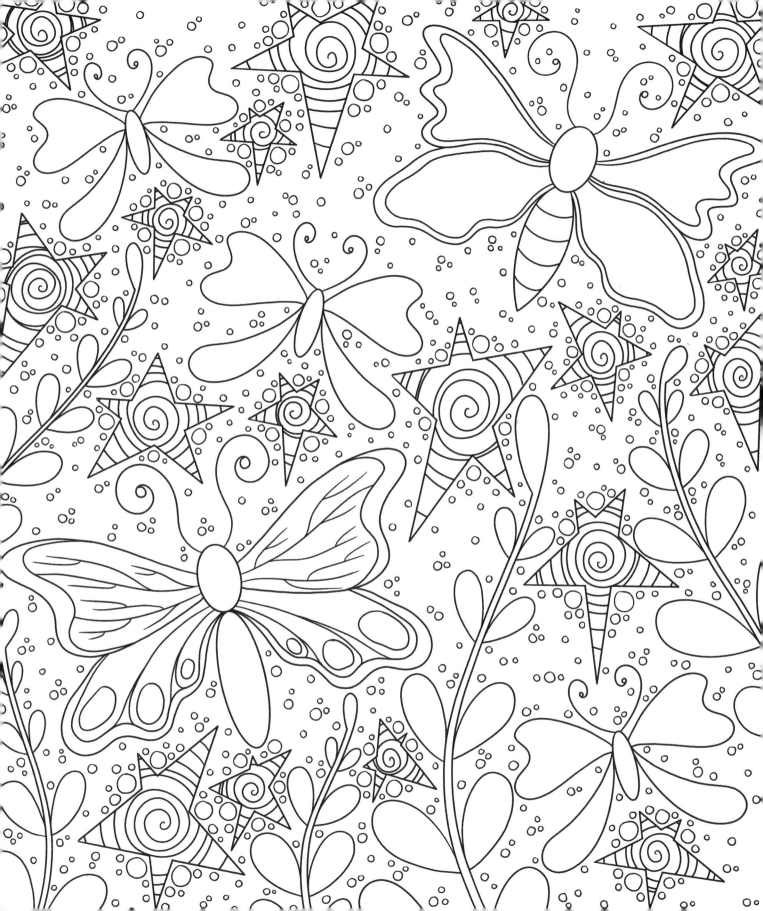

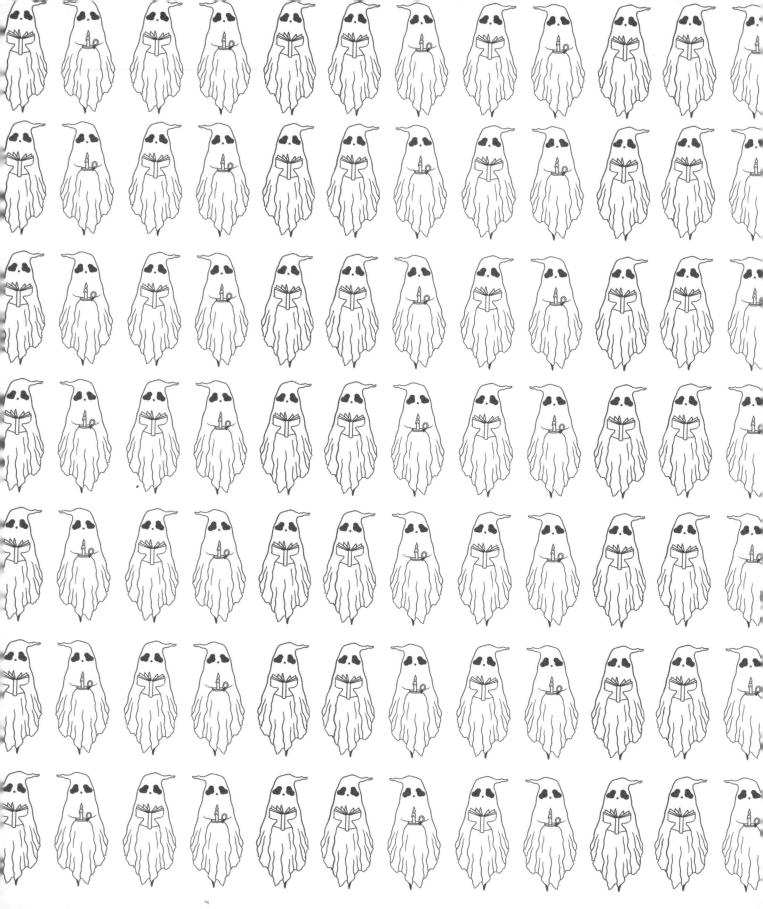

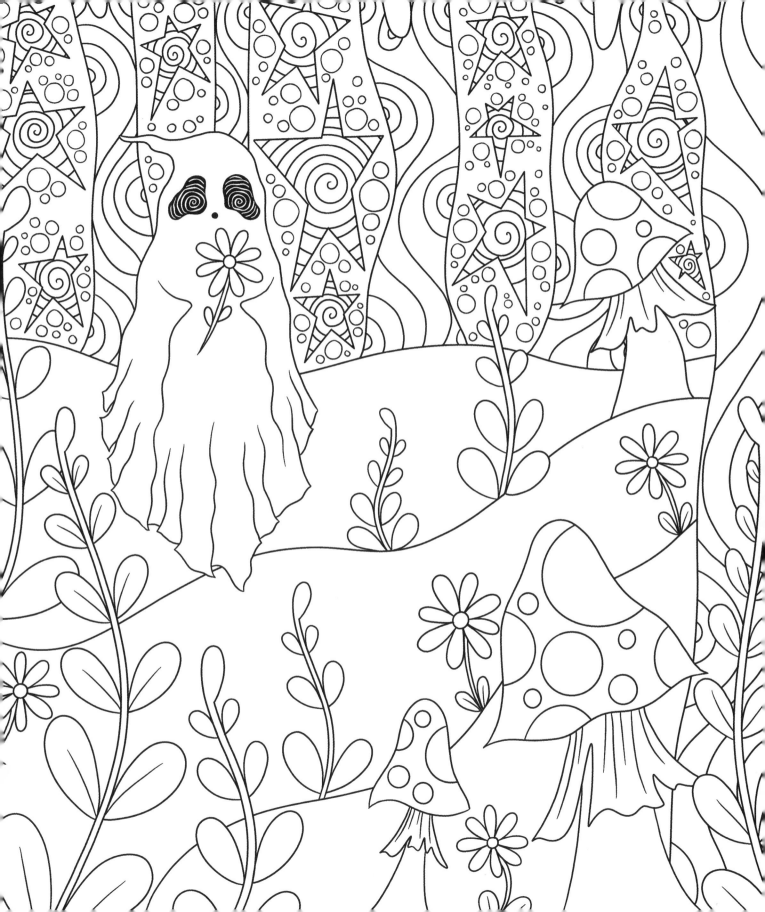

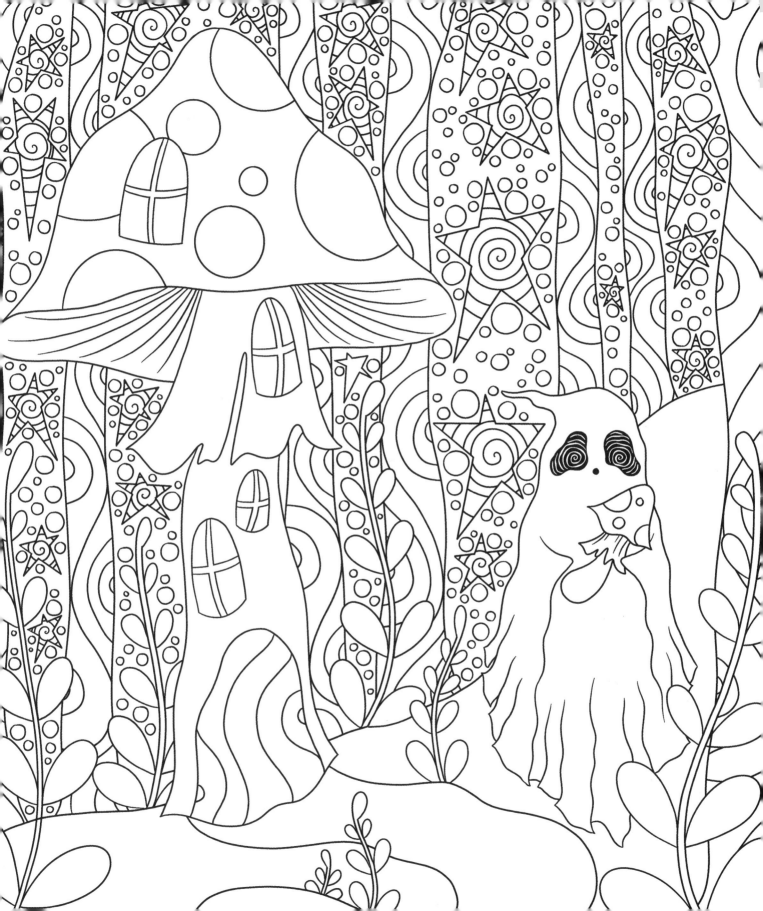

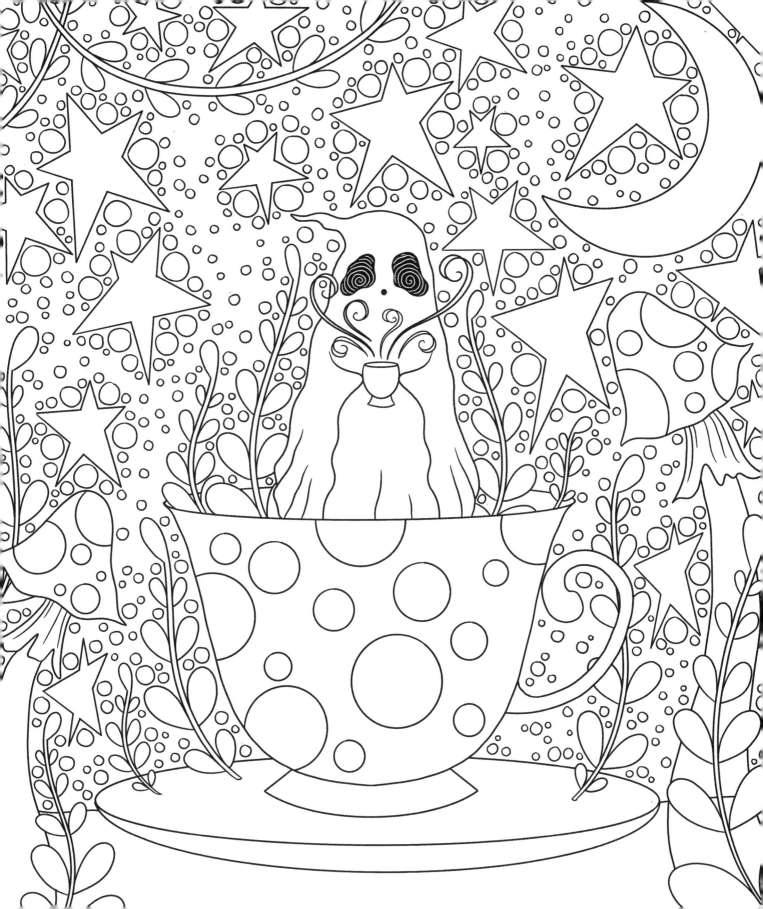

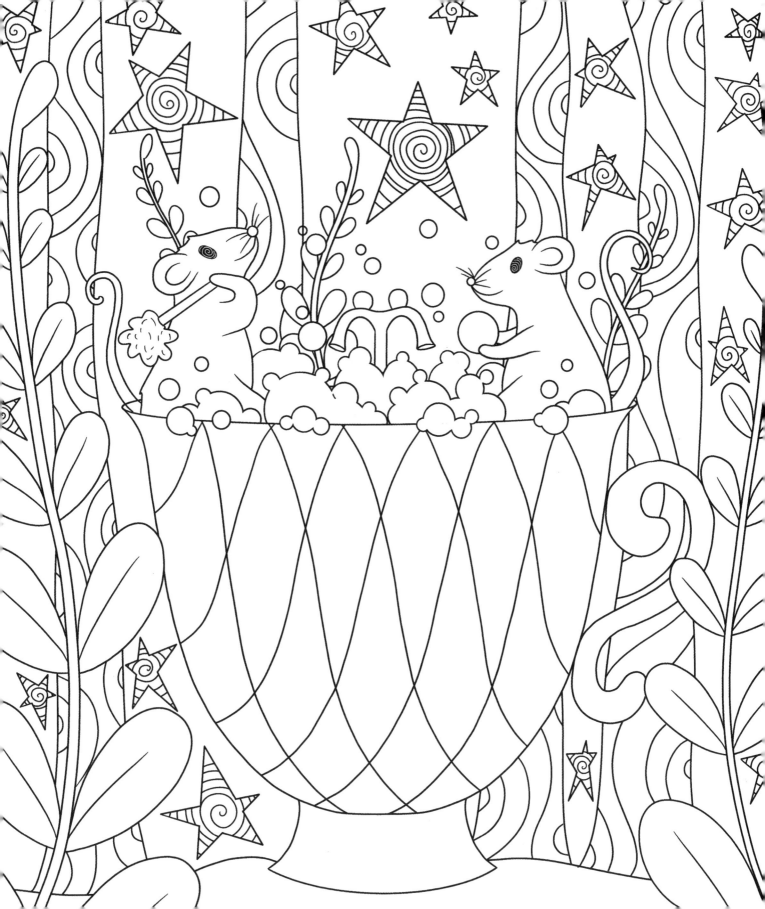

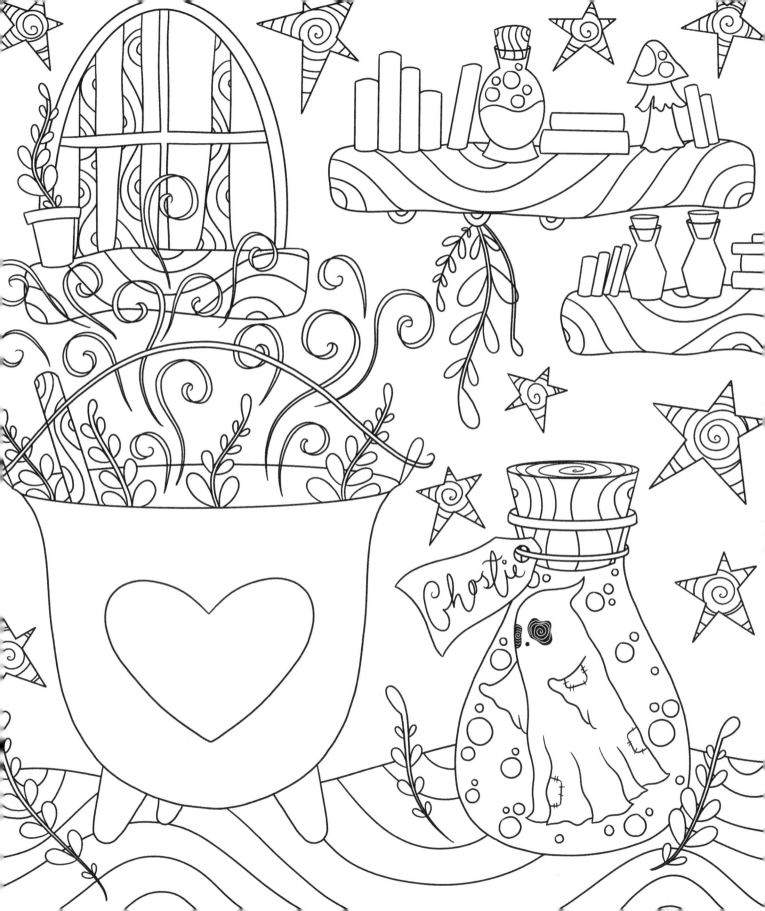

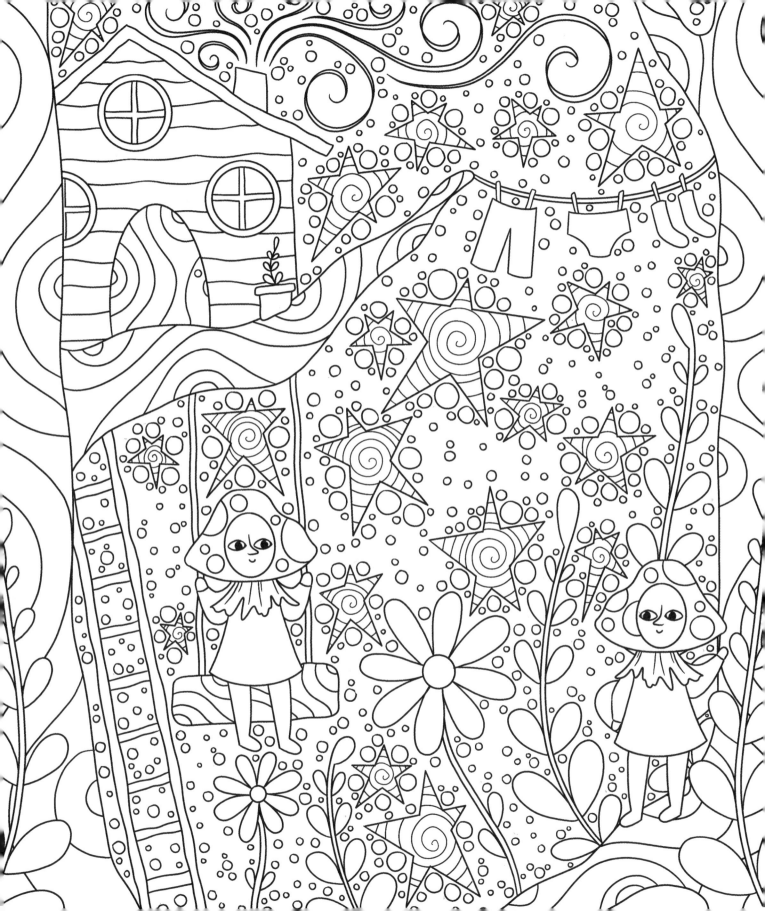

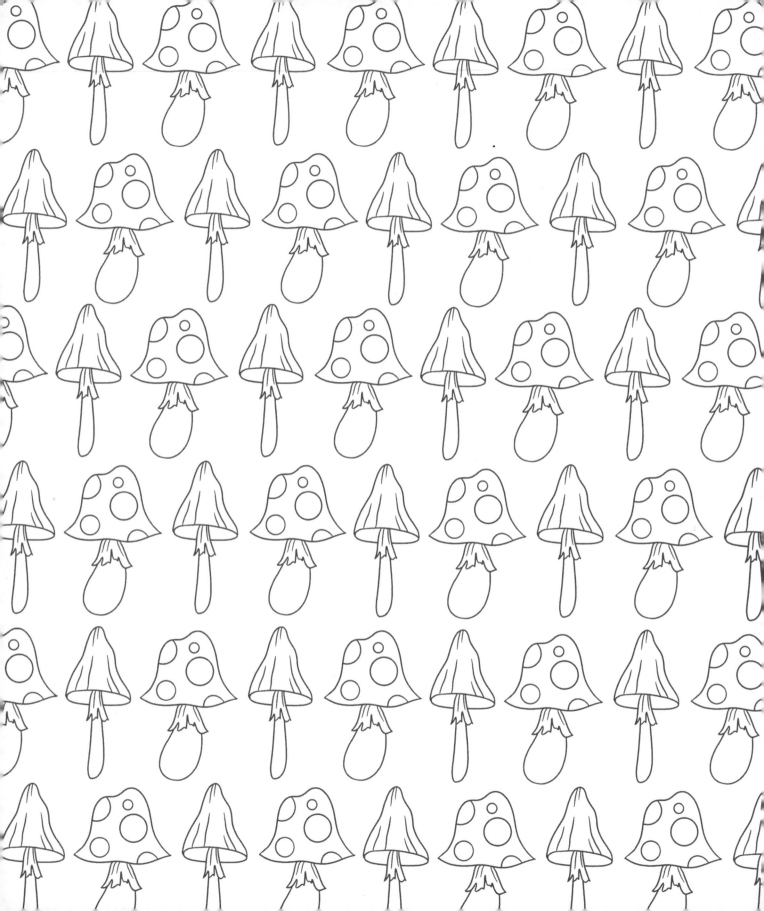

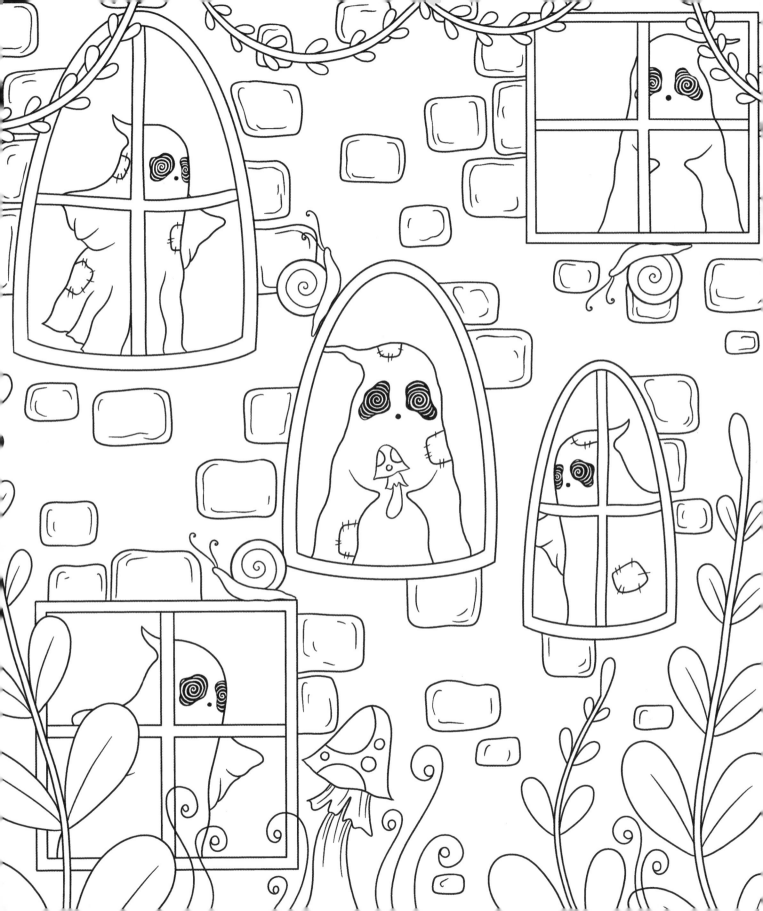

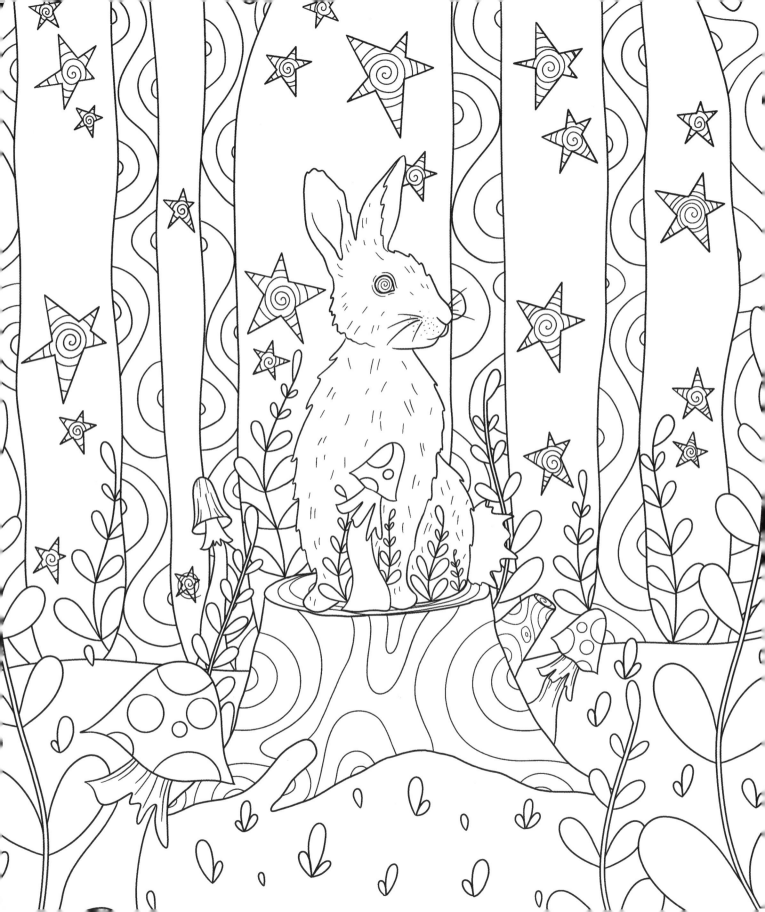

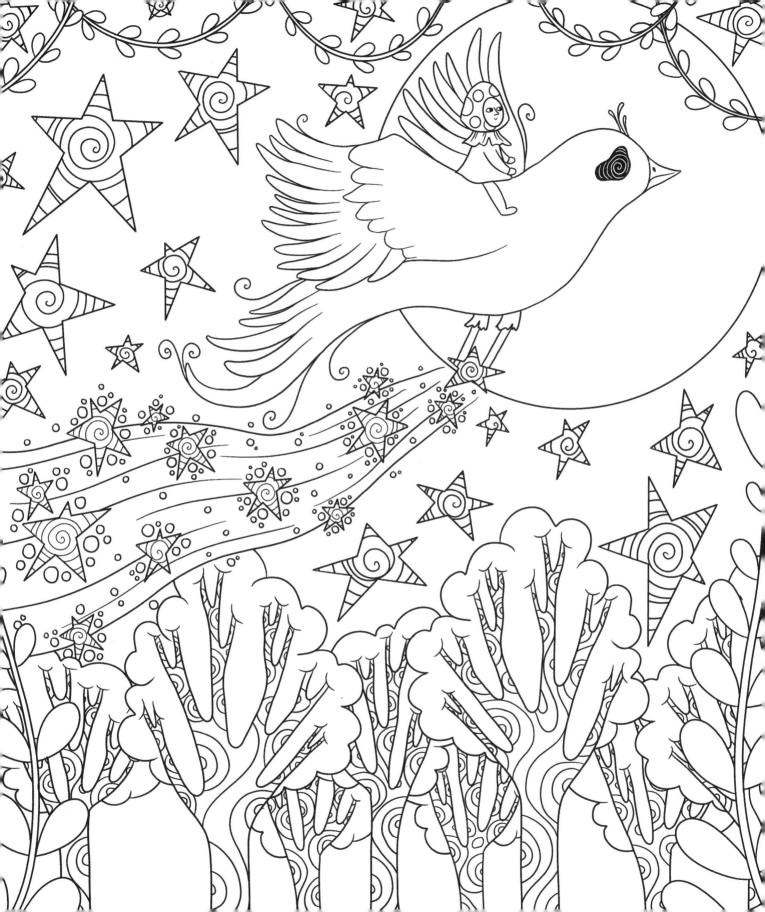

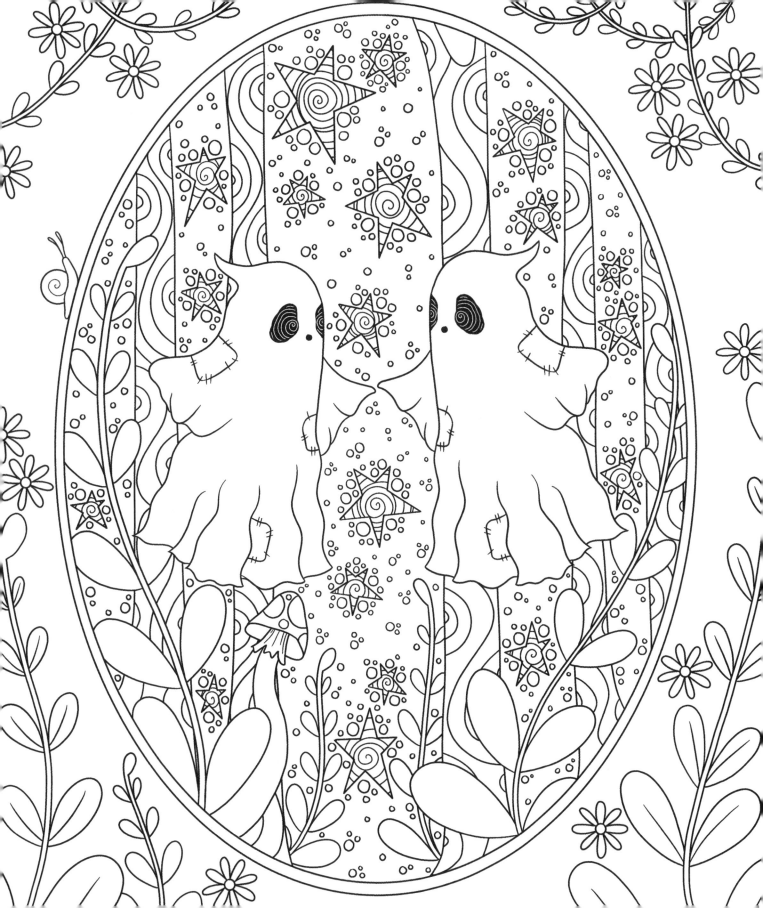

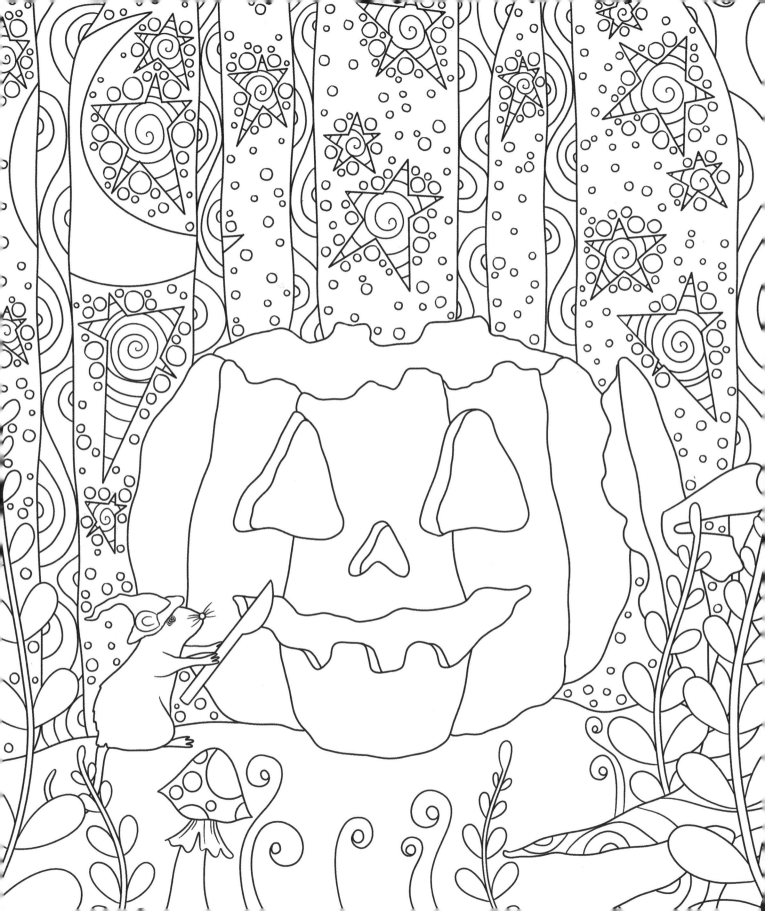

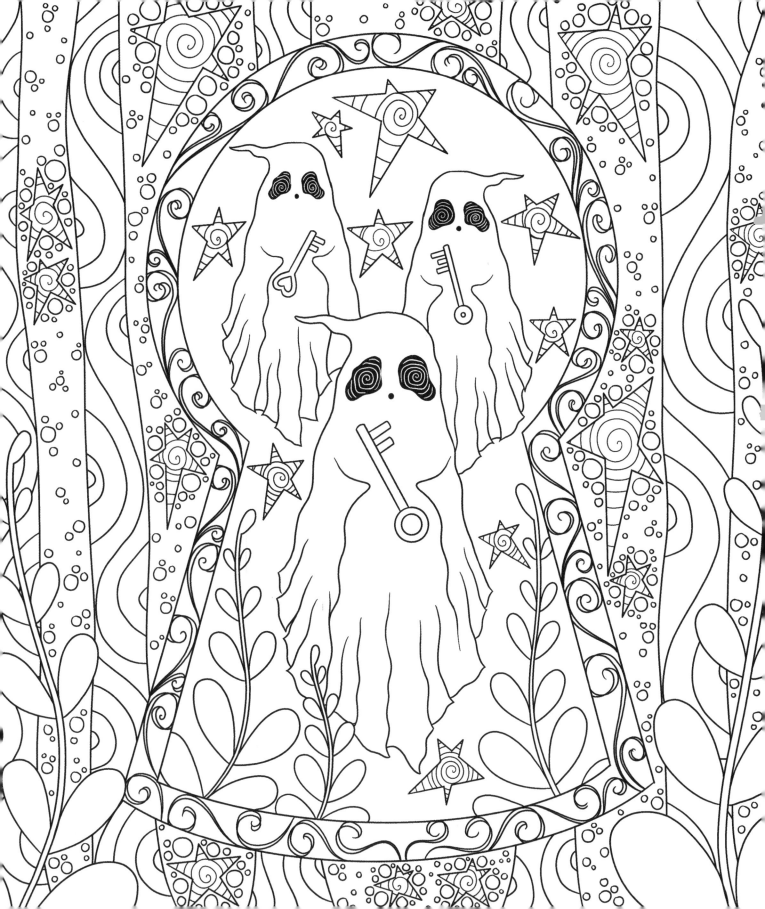

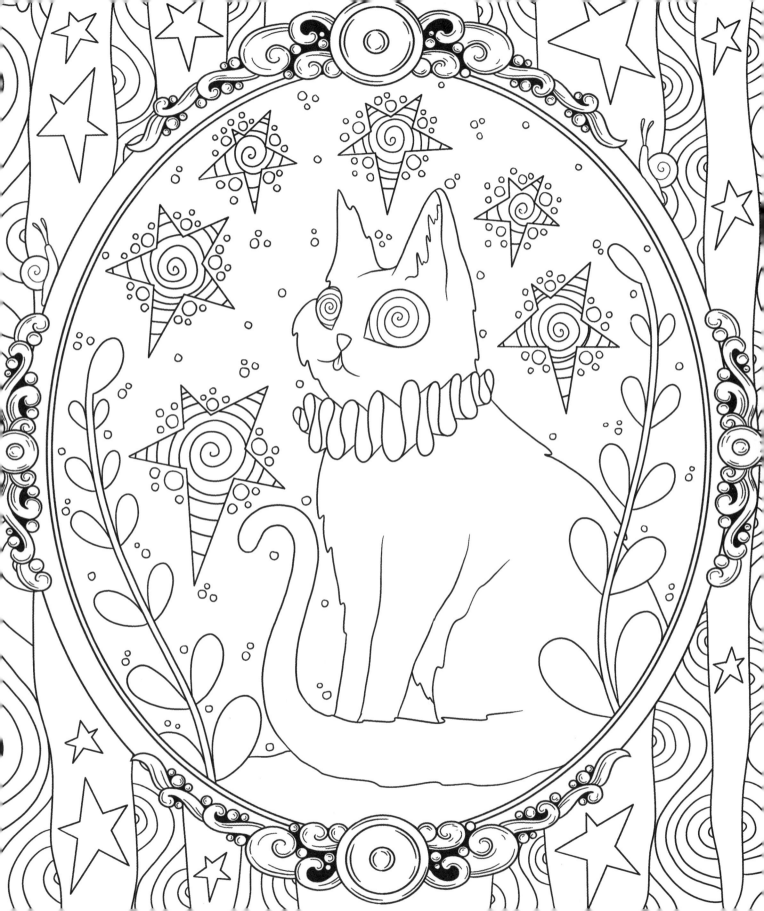

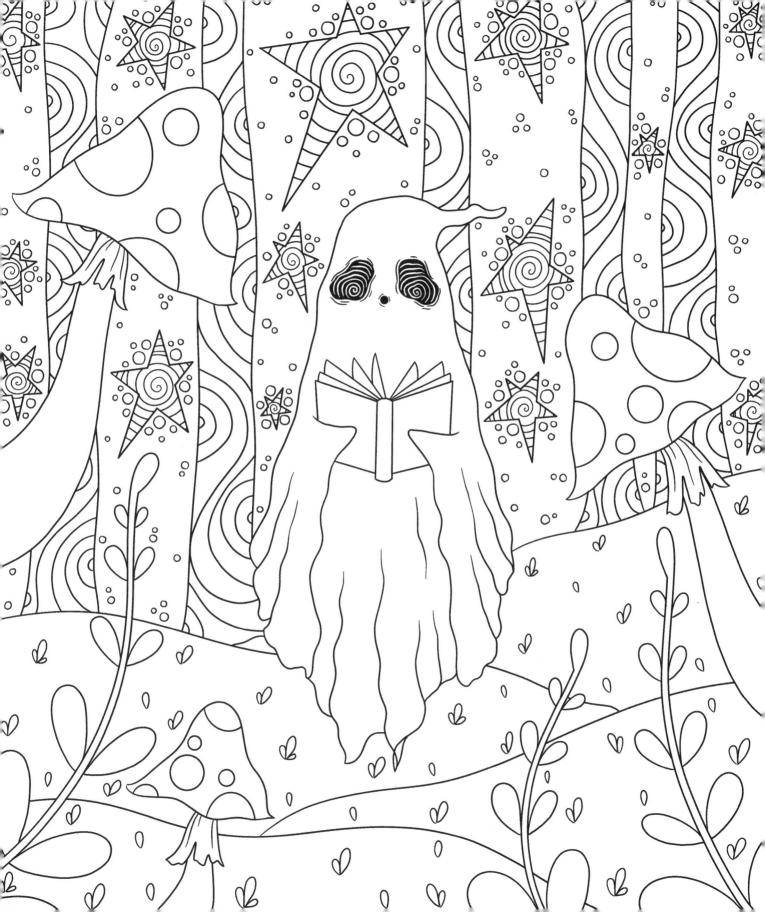

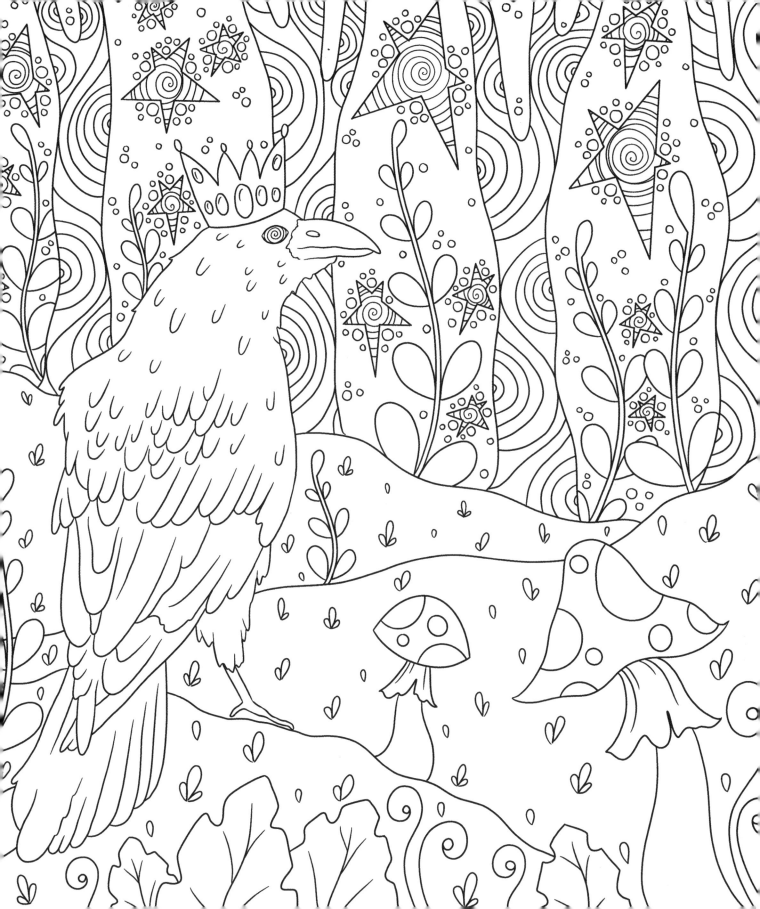

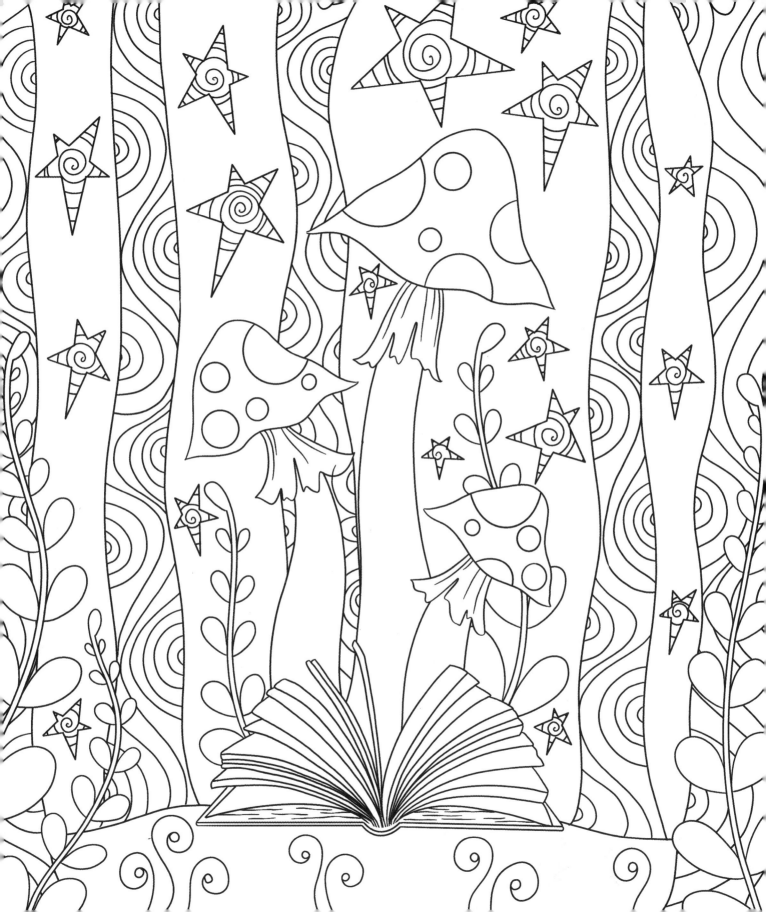

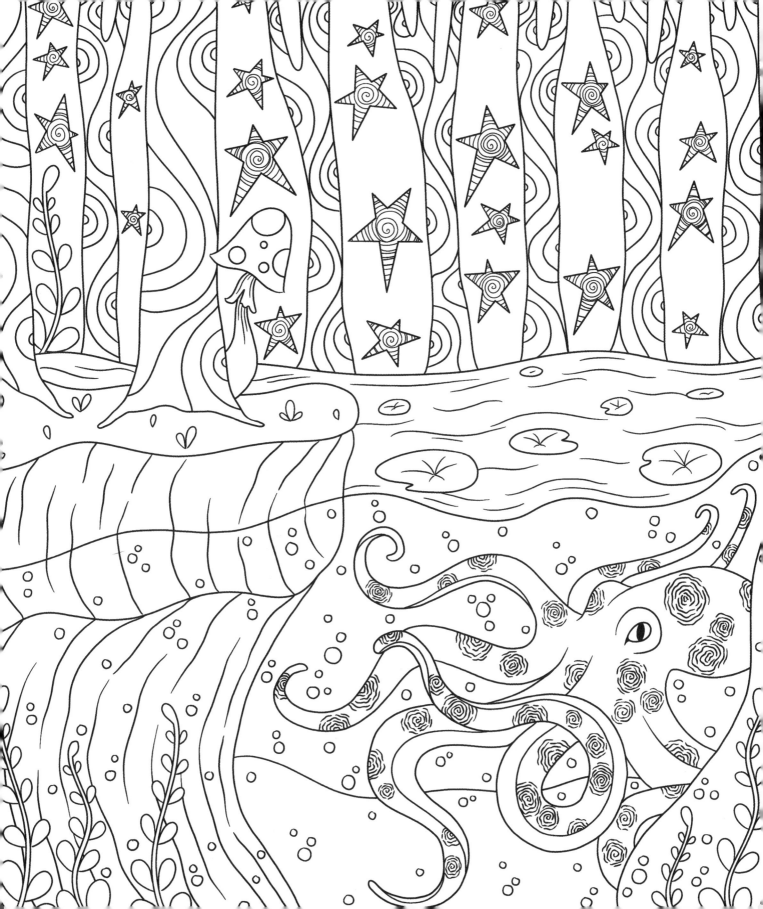

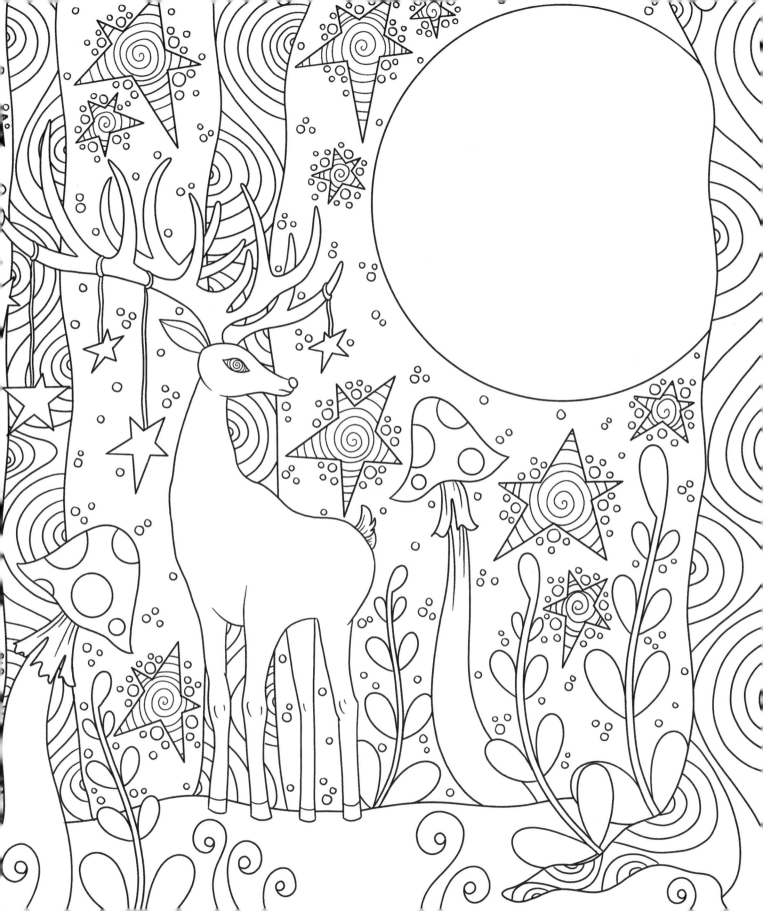

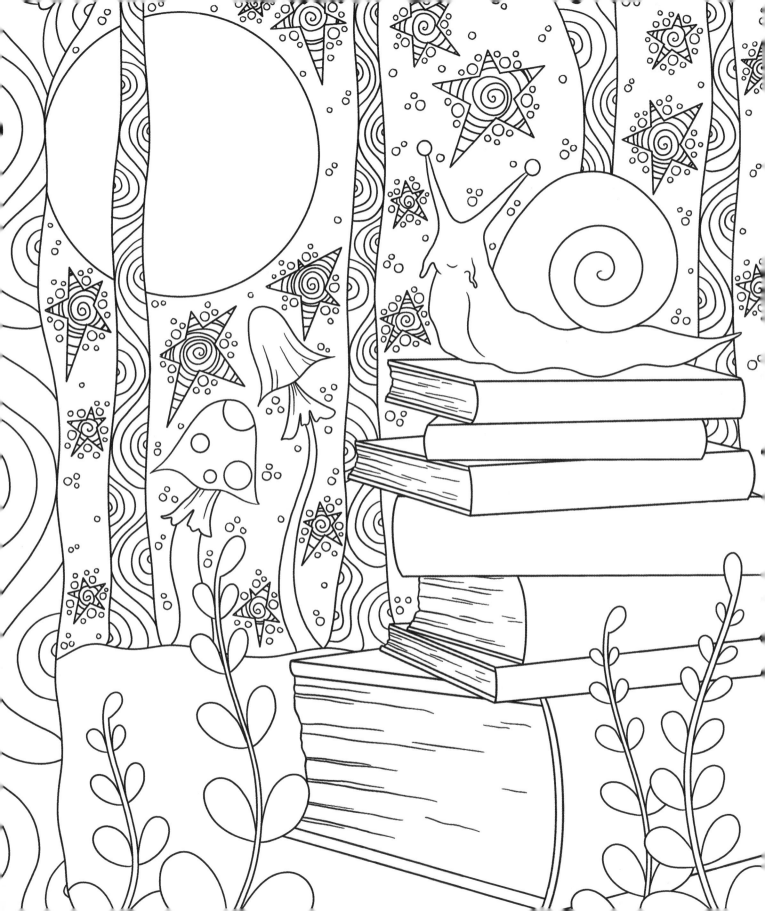

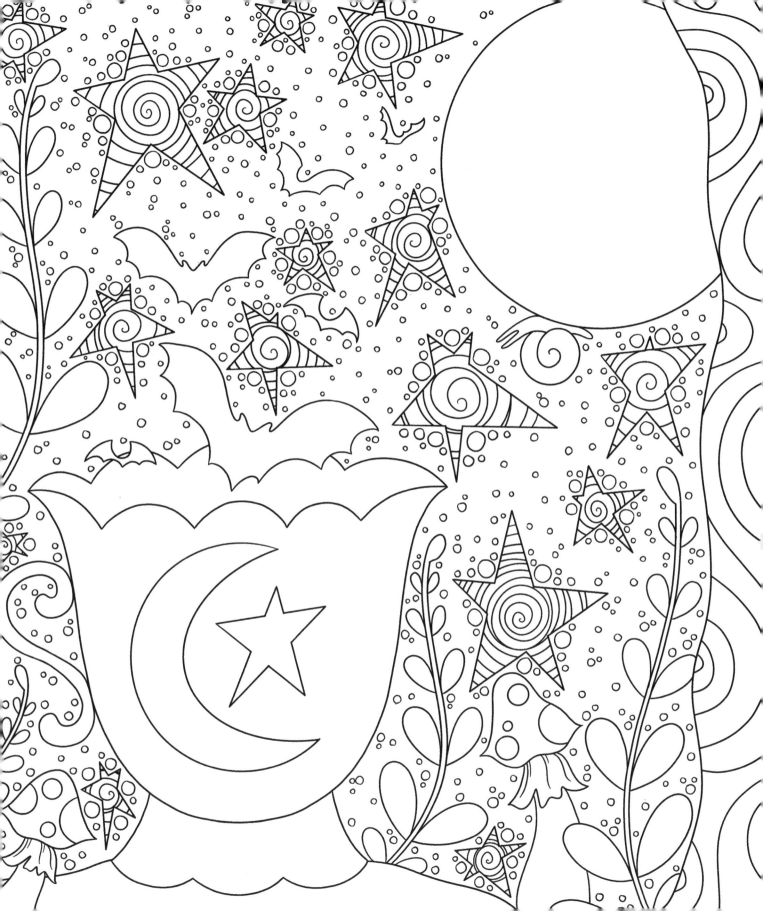

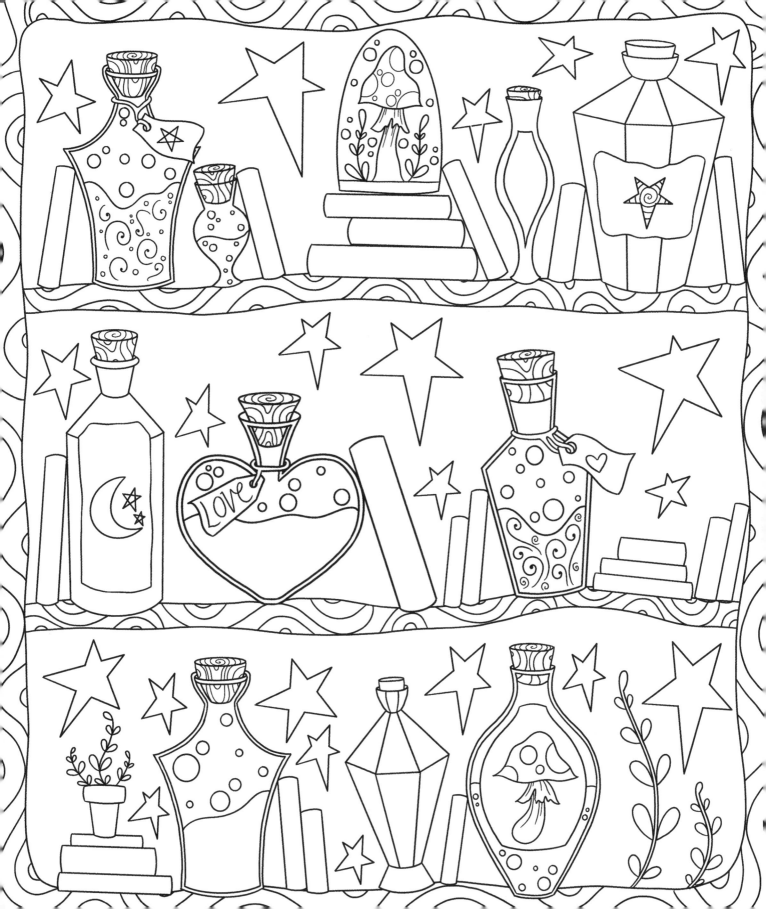

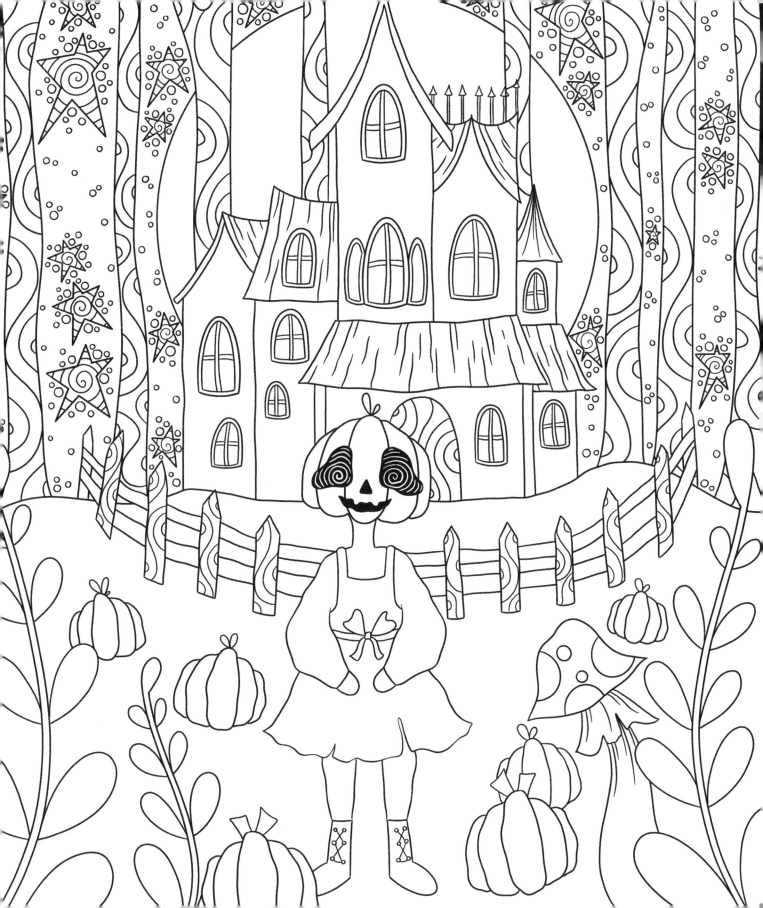

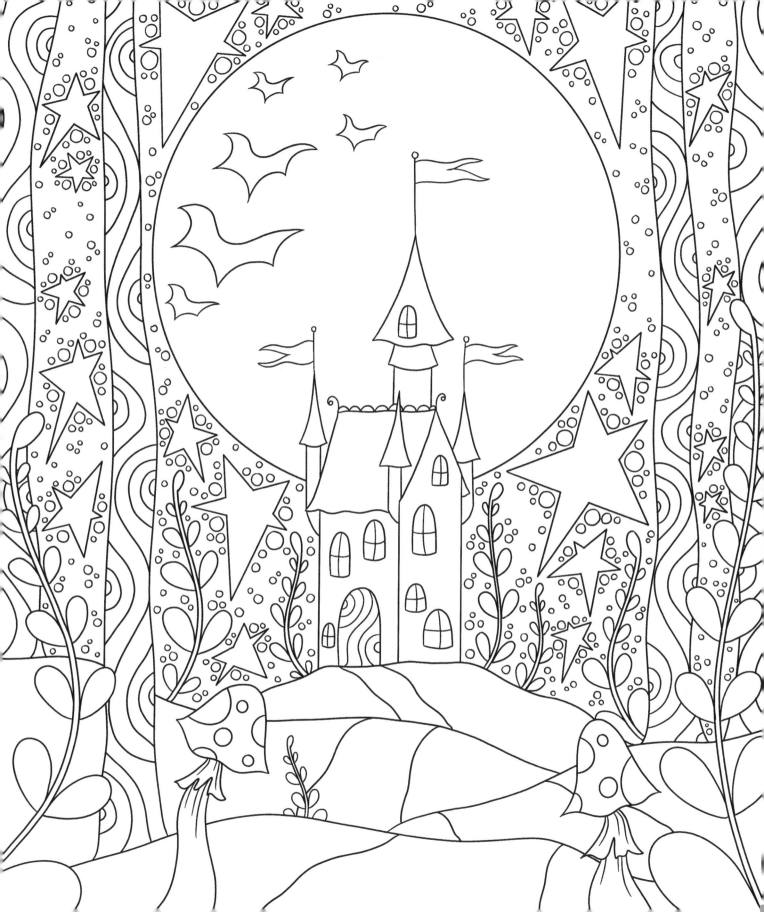

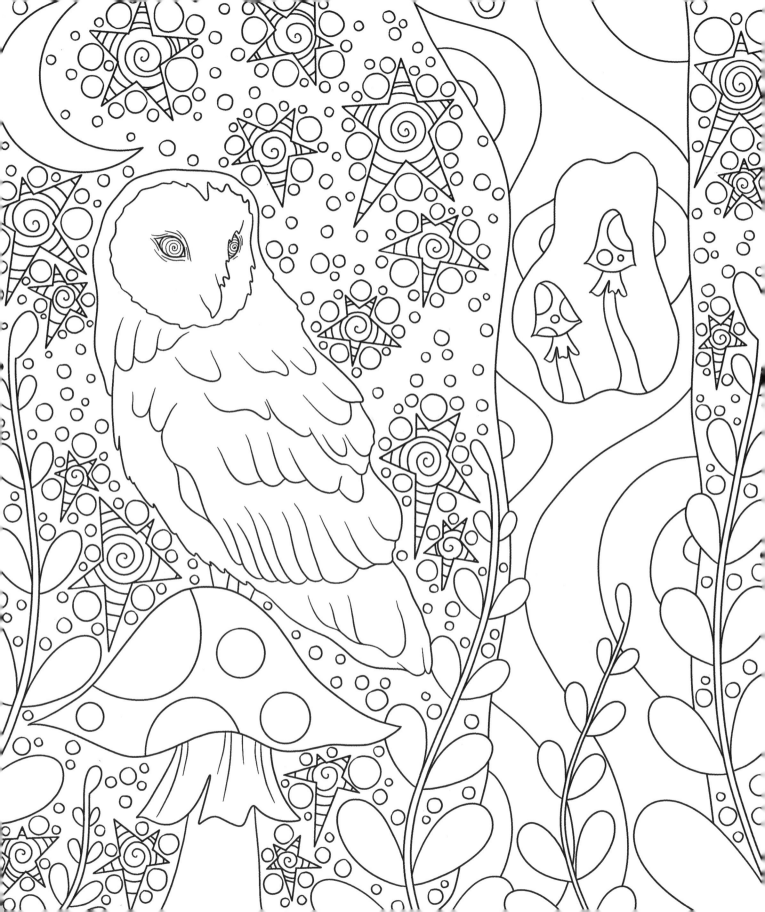

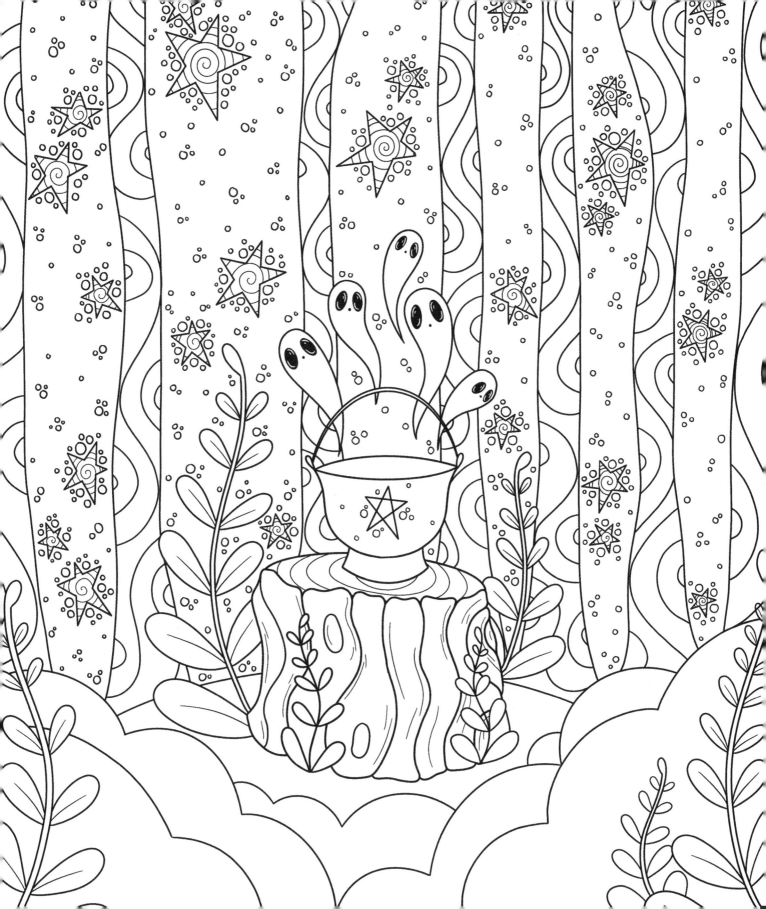

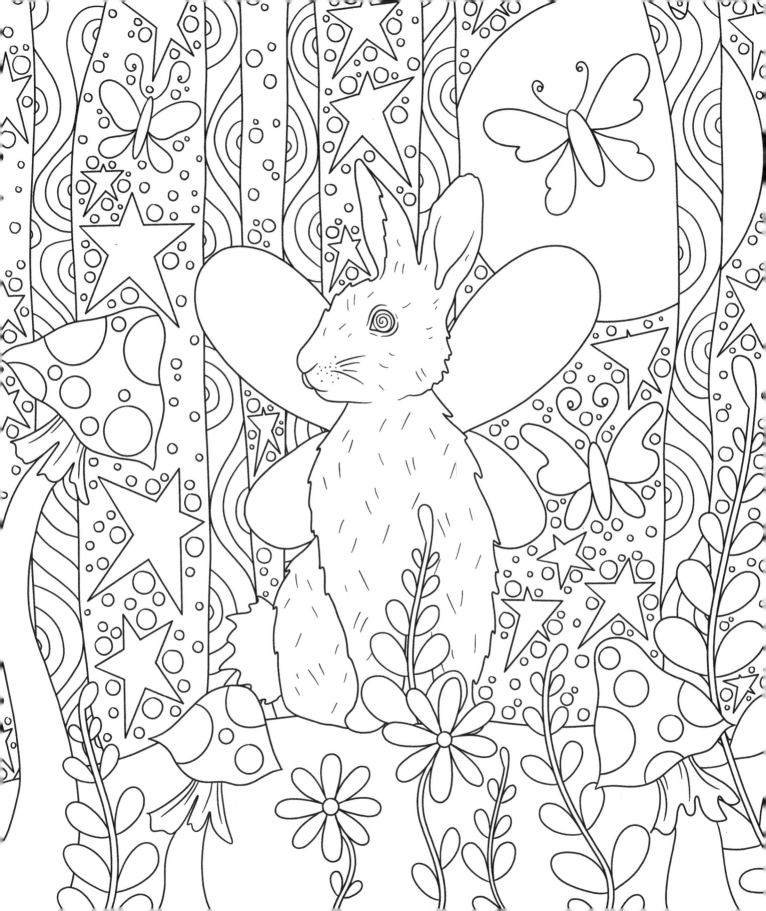

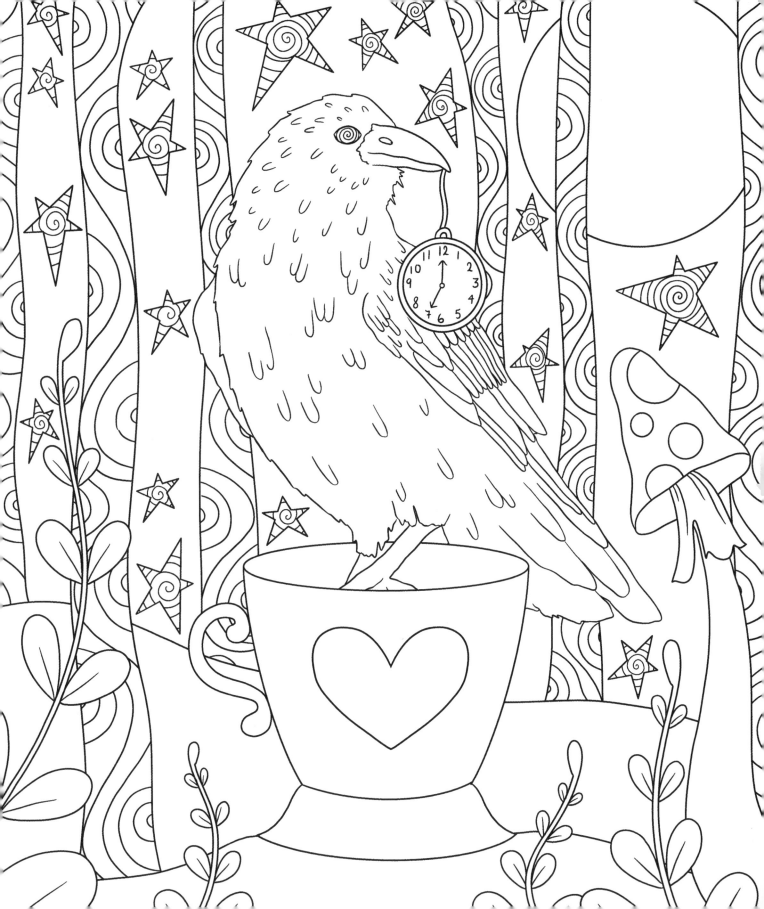

First published in 2023 by Rock Point, an imprint of The Quarto Group,
142 West 36th Street, 4th Floor, New York, NY 10018, USA
T (212) 779-4972 F (212) 779-6058 www.Quarto.com

Rock Point titles are also available at discount for retail, wholesale, promotional and bulk purchase. For details, contact the Special Sales Manager by email at specialsales@quarto.com or by mail at The Quarto Group, Attn: Special Sales Manager, 100 Cummings Center Suite, 265D, Beverly, MA 01915, USA.

10 9 8 7 6 5 4 3

ISBN: 978-1-63106-910-9

Publisher: Rage Kindelsperger
Creative Director: Laura Drew
Managing Editor: Cara Donaldson
Editor: Sara Bonacum

Printed in the USA